C000215898

NORFOLK
THROUGH TIME
Michael Rouse

AMBERLEY PUBLISHING

To those I meet on my travels who take an interest,
and share their knowledge with me.

First published 2014

Amberley Publishing
The Hill, Stroud
Gloucestershire, GL5 4EP

www.amberley-books.com

Copyright © Michael Rouse, 2014

The right of Michael Rouse to be identified as the
Author of this work has been asserted in accordance
with the Copyrights, Designs and Patents Act 1988.

ISBN 978 1 4456 3625 2 (print)
ISBN 978 1 4456 3653 5 (ebook)

All rights reserved. No part of this book may be
reprinted or reproduced or utilised in any form
or by any electronic, mechanical or other means,
now known or hereafter invented, including
photocopying and recording, or in any information
storage or retrieval system, without the permission
in writing from the Publishers.

British Library Cataloguing in Publication Data.
A catalogue record for this book is available from
the British Library.

Typesetting by Amberley Publishing.
Printed in the UK.

Introduction

Growing up in Ely, once in the Isle of Ely and now in Cambridgeshire, neighbouring Norfolk represented our nearest way to the seaside and the excitement of forests, compared with the flat fenlands and agricultural landscape around us. As a child, the family holidays were often spent at Hunstanton or Great Yarmouth, so I have great affection for those places. There are memories of long, slow car journeys to get to these places, going through every town and village before the days of bypasses, especially to Great Yarmouth, as Norfolk is a very large county.

Norfolk, dubbed 'Nelson's County' since 2004 after Horatio Nelson (1758–1805), the county's greatest national hero, has an area of over 2,000 square miles. As it is largely an agricultural county, there is low population density, with numerous small villages linked to their nearest market towns by small, winding country lanes. The towns themselves do their best to manage the growing number of cars with one-way traffic schemes.

Norwich, the county capital, is by far the largest settlement. The A11, currently being upgraded with major dualling works, is the main road connecting the county with the M11 to London and the A14 to the Midlands, while the heavily used A47 takes traffic across North Norfolk to King's Lynn and through West Norfolk to Cambridgeshire and Lincolnshire.

It is a county of great variety. For this book, I have divided Norfolk up into broad areas, beginning with perhaps the lesser known area west of the River Ouse and the A10, which is flat land largely reclaimed from the sea. Then I have visited the Brecks, or Breckland. The Brecks were medieval heathland, gorse-covered miles of sand dunes and shingle, where rabbits were once farmed on an industrial scale, with the warrens still visible. The principal market towns are Swaffham, Dereham, Watton and Thetford. Around Thetford is the largest lowland pine forest in the UK managed by the Forestry Commission,

which has existed since 1919, tasked with replacing forests lost during the First World War and before.

After visiting some of the other market towns, the penultimate stop is Norwich, that fine cathedral city and administrative capital. Then we venture into the fascinating Broads, a national park since 1989, before taking a drive along the wonderful coast from Hunstanton to Great Yarmouth and Gorleston. Along the north-east coast I have seen some of the damage caused by the tidal surge and storms from December last year, when sea levels were higher than in 1953.

In all, I have travelled over 1,000 miles, but can only give a partial view of what is a wonderful county. All of my photographs were taken in May and June this year, before the summer season really got underway and many of the seaside resorts became busy with holidaymakers and trippers.

Acknowledgements

I have referred to *Coastal Resorts of East Anglia*, which I wrote for Terence Dalton Ltd in 1982; the *AA Guide to Norfolk and Suffolk*, 2014, and various websites and guides. I am grateful to Dereham Library, Norwich Tourist Information Centre, Great Yarmouth TIC, the Ferry Inn at Horning Ferry, and receptionists at Seacroft, Hemsby and Hemsby Beach Holiday Park. My thanks to those in the Beach Coffee House and Fish and Chips Café at Sea Palling, not least for the fish and chips. As always, my thanks to all at Amberley Publishing.

Michael Rouse
Ely, June 2014

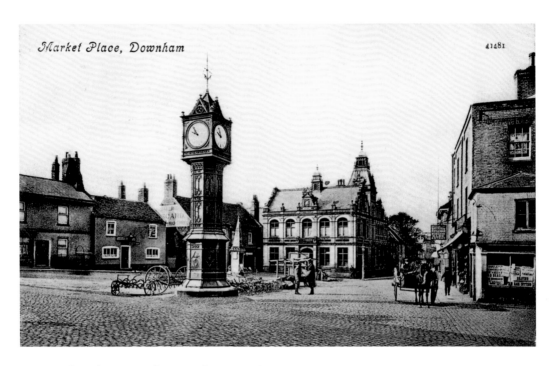

Market Place, Downham Market, *c.* 1906

Downham Market is a clean, busy, small market town that used to straddle the A10, but is now bypassed. Alongside the River Ouse, it sits between the fenland of West Norfolk and the more familiar Norfolk that many tourists recognise. The marketplace was once renowned for its butter market and horse fairs. The splendid Victorian clock tower was built in 1878 and now graces a marketplace that was remodelled in 2004 with the market now held behind the fine town hall seen in the centre.

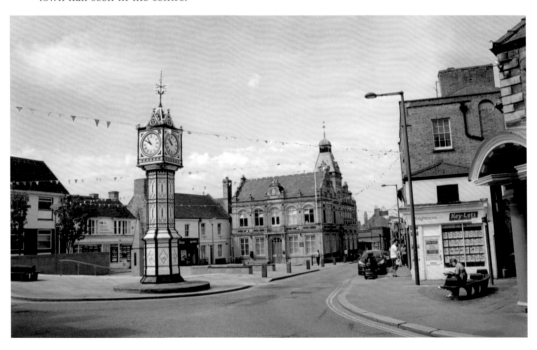

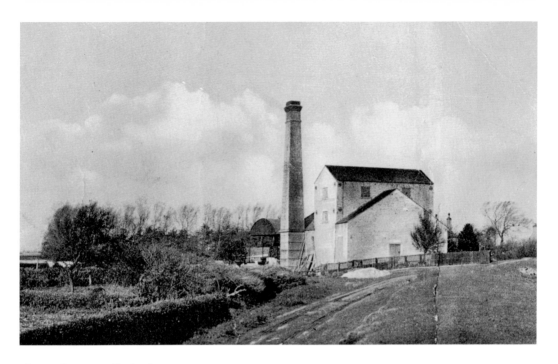

The Engine Ten Mile Bank, *c.* **1914**
Much of the land west of Downham Market was reclaimed from the sea and the fen waters in the seventeenth century. The old Ten Mile Bank Engine was built in 1819/20 and later enlarged in 1842, to take water from the large drainage dyke into the River Ouse, known at this man-made section as the Ten Mile River. Falling land levels meant that the Littleport and Downham Internal Drainage Board built a new pumping station and cut a new drain in 1976. The old pump house is a now a private residence.

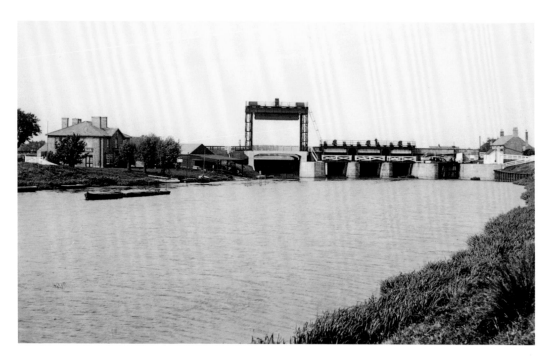

Denver Sluice

Denver Sluice is the Environment Agency's nerve centre that controls the fenland waters. The first sluice was built by Sir Cornelius Vermuyden in 1651. Vermuyden's sluice was destroyed by flood tides in 1713, but replaced between 1748 and 1750 by a new sluice that had a navigation channel for boatmen. Denver keeps the seawater from flooding into the low-lying fens and allows the river water out into the Wash. From Denver, water is also sent down to Essex.

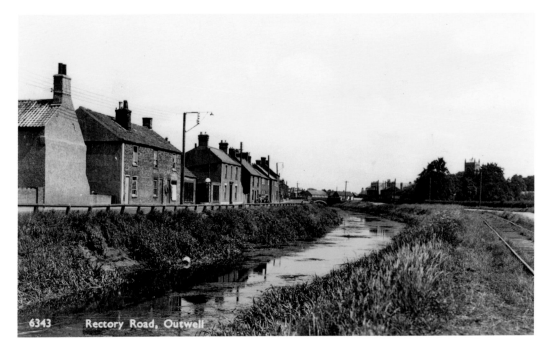

6343 Rectory Road, Outwell

Rectory Road, Outwell, c. 1960

The Well Creek declined after the seventeenth-century fen drainage. In the late eighteenth century the Outwell – Wisbech canal was cut, taking in some of the old river, but it suffered from silting up and it declined further after 1883 when a small tramway was built from Upwell to Wisbech (the line can be seen on the right). The line closed to passengers in 1928 and to goods in 1966, before it was taken up. Between 1950 and 1970 the canal was filled in. The Well Creek Trust restored the river for navigation.

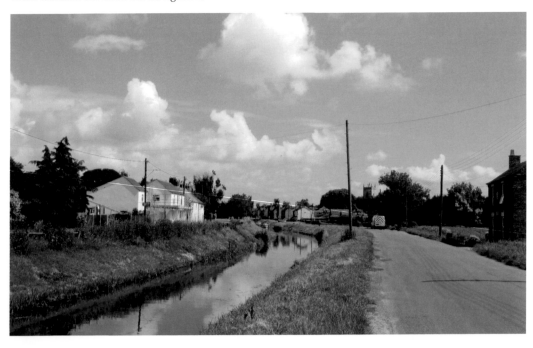

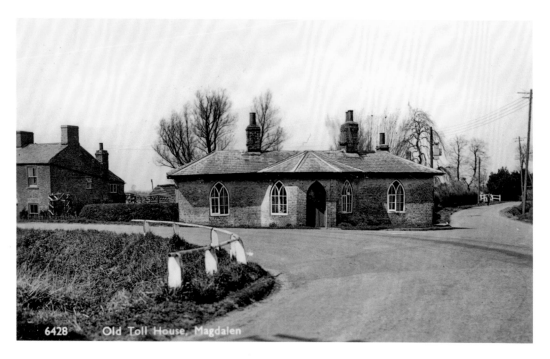

Old Toll House, Magdalen, *c.* 1960

Standing at the junction of Magdalen High Road and the Fitton Road, this toll house is a reminder of the turnpike roads that were developed in the eighteenth century by individual Acts of Parliament to provide better roads, funded by the collection of tolls. Turnpike roads were abolished in the 1870s. The unusual toll house, with its nearby verges maintained by a local resident, provides a picturesque feature at the roadside.

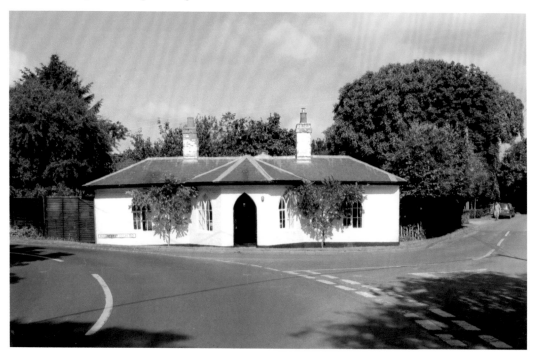

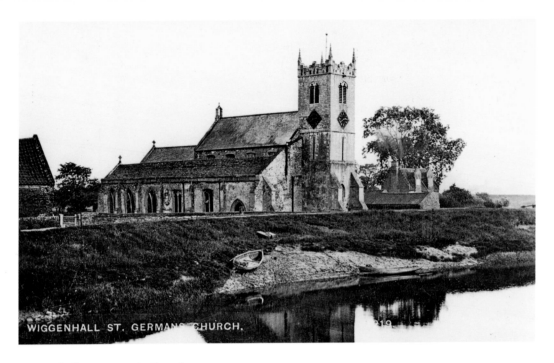

WIGGENHALL ST. GERMANS CHURCH.

Wiggenhall St German's Church, *c.* 1930
A curiosity of this part of the fens are the small hamlets designated by the name of the church, as with Wiggenhall St Germans, Wiggenhall St Mary and Wiggenhall St Peter. St Germans is an unusual dedication to St Germain. The church nestles beside the River Great Ouse, where its high banks prevent the area from being under water. Nearby at Saddlebow is one of the largest pumping stations in Europe, constructed in 2010 on the 1848 main drain to pump water into the Great Ouse and protect the land.

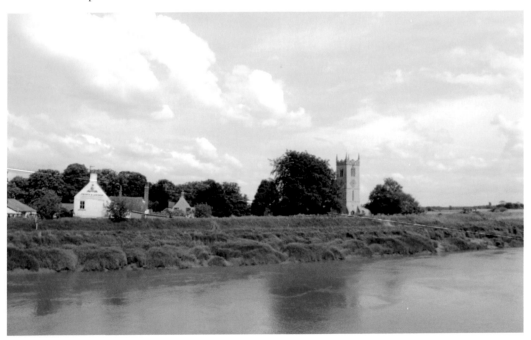

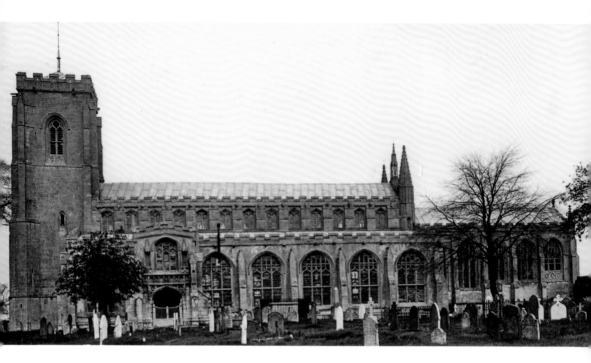

The Church at Walpole St Peter's, c. 1960

'The Queen of the Marshland' or 'The Cathedral of the Fens', St Peter's is a glorious large, light church. A sea-flood in 1337 destroyed the original church except from the tower. This fourteenth-century church is a testimony to the wealth of the wool trade. It is said that St Peter's was the inspiration for the church in Dorothy L. Sayer's classic 1934 crime story *The Nine Tailors*. An extraordinary feature of the church is the bolthole that goes underneath the high altar where horses were once stabled during services.

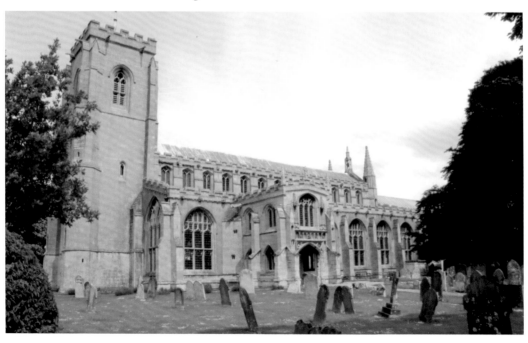

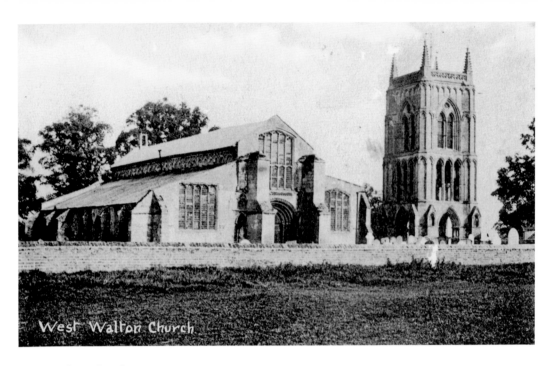

West Walton Church

West Walton Church, c. 1920

Another unusual Norfolk fenland church is St Mary's, which was mostly built in the thirteenth century and has a detached bell tower. Built in 1250, the campanile was probably sited away from the church because of the need to find firm foundations for such a heavy structure. It is now the responsibility of the Churches Conservation Trust, which has replaced all the floors, but the bells cannot be rung as the medieval timbers are no longer strong enough.

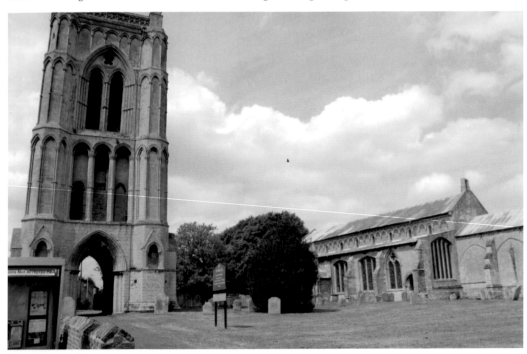

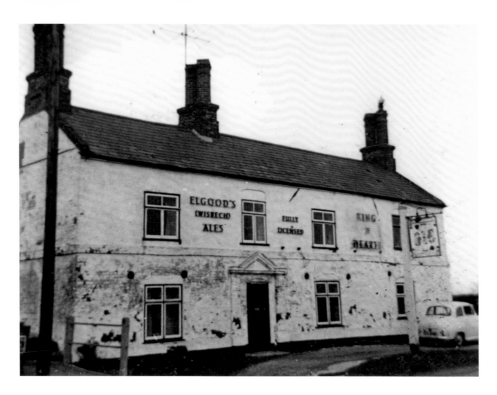

The King of Hearts, West Walton, c. 1960

The King of Hearts is a popular and busy village public house and carvery standing on the main road right next to St Mary's church. The first recorded licensee was in 1794. Located less than 3 miles from Wisbech, the King of Hearts is one of many public houses owned by the independent Wisbech brewer Elgood's, which has been trading since 1795.

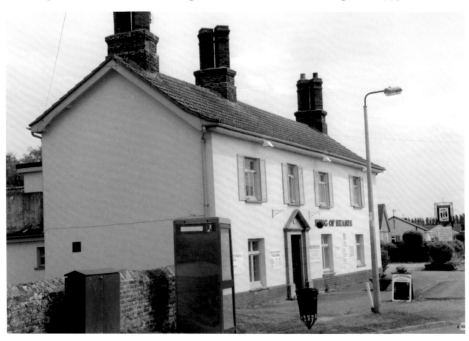

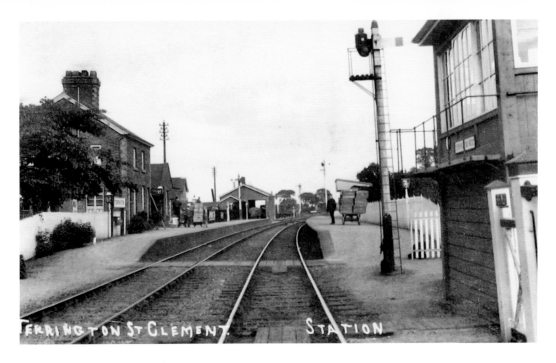

Terrington St Clement Station

Terrington St Clement railway station was opened in 1866 on the Midland & Great Northern Joint Railway, known to the locals as the 'Muddle and Get Nowhere'. The hub of the M&GN was at Melton Constable in Norfolk and the station here was on the cross-country line to the Midlands. Some way outside the neat little village itself, the line and station were closed in 1959. There is nothing to see of the old line now, but the African Violet Centre is close to where the station once stood.

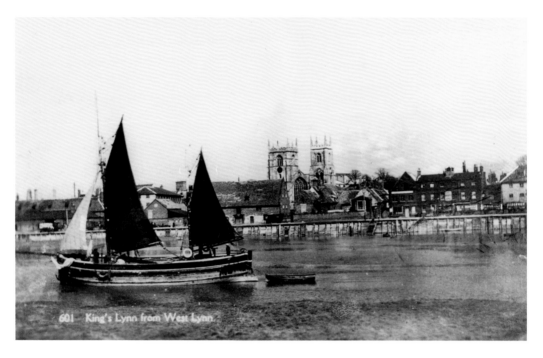

King's Lynn from West Lynn, *c.* 1955

The western bank of the Great Ouse provides a splendid view of the ancient port of Lynn. Here there is a ferry that has been in operation since 1285, with the alternative being a long walk around to reach the town. The Millenium Walkway stretches along part of this bank and takes keen walkers onto the Sir Peter Scott Walk of some 13½ miles along the old sea bank of the Wash to his former lighthouse home at Sutton Bridge.

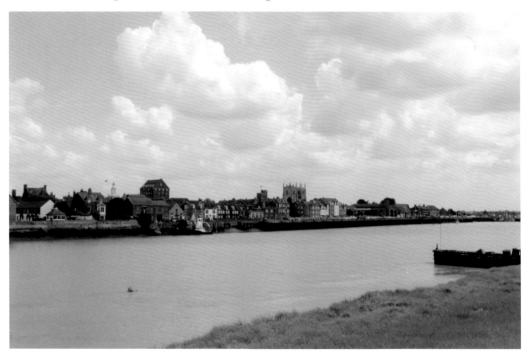

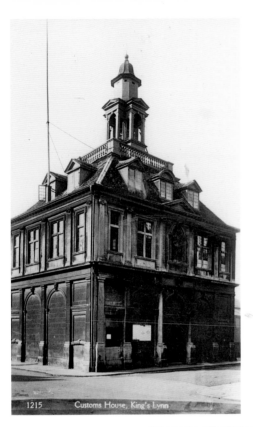

1215 Customs House, King's Lynn

Customs House, King's Lynn

King's Lynn's origins go back to 1101, when Bishop Herbert de Losinga of Thetford founded the medieval town by building the church of St Margaret, now King's Lynn Minster, between the Purfleet and the Mill Fleet. The customs house at Purfleet, which is now a tourist information centre, has looked out over the activities of the port for over 300 years. The town grew wealthy as a member of the Hanseatic League, trading with merchants from Germany and the Baltic ports. The customs house has various displays recalling Lynn's maritime history.

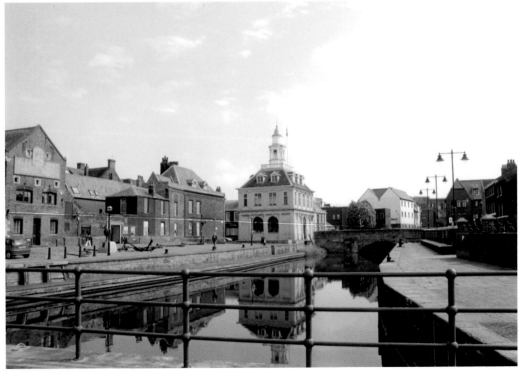

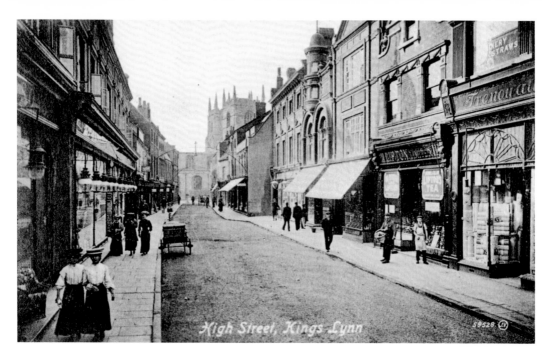

High Street, King's Lynn, *c.* 1912

The twin towers of the minster can be seen in the background. In 1204, a charter from Bishop John de Grey of Norwich renamed the town Bishop's Lynn. The town grew wealthy on trade and there are many wonderful merchants' houses and great buildings, which include the ancient guildhall opposite the minster, reflecting the town's rich history. Bishop's Lynn changed its name again during the reign of Henry VIII, becoming King's Lynn.

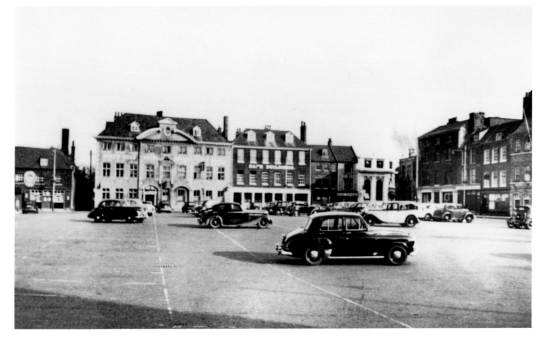

Tuesday Market Place, King's Lynn, c. 1965
King's Lynn has had a market since its foundation. The Saturday market takes place next to the minster. The larger Georgian marketplace, for markets held on a Tuesday, is one of the country's finest town squares and is surrounded by historic buildings, ancient inns and a corn exchange which is now a popular entertainment venue. For lovers of England's rich heritage, King's Lynn offers everything for the visitor. It also has many leading businesses in industrial areas on the town's edge, and continues to develop as Norfolk's third largest town.

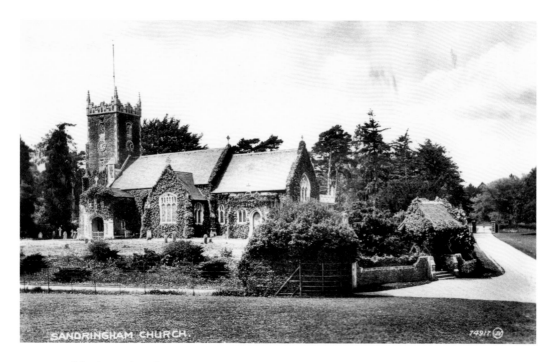

Sandringham Church

King's Lynn is now bypassed by the A10. Continuing north along that road leads to one of the most beautiful parts of the county, with pine forests and miles of colourful rhododendrons. Sandringham House, set in a lovely park, was built in 1870 for the Prince and Princess of Wales, later King Edward VII and Queen Alexandra. The royal family continue to use Sandringham as a holiday retreat and visit this pretty little carrstone church of St Mary Magdalene on the estate.

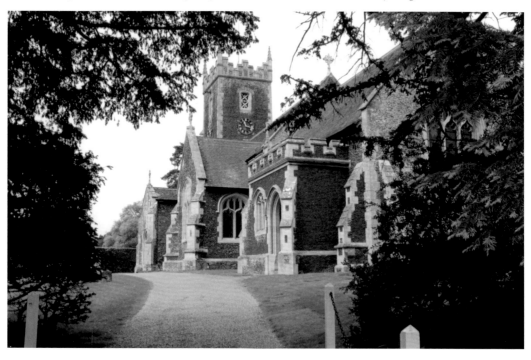

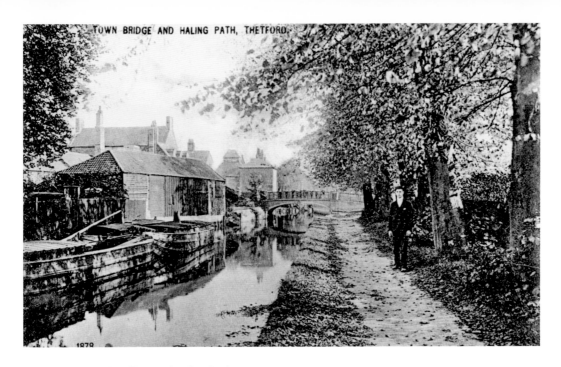

Town Bridge and Haling Path, Thetford, *c.* 1910
The origins of Lynn take us down to Thetford on the Suffolk border. Thetford is an ancient market town on the A11. The road now bypasses the town and has led to the development of large industrial areas and out-of-town retail units. Nearby is the vast Thetford Forest, maintained by the Forestry Commission. It is claimed that Thetford was the royal residence of Boudicca. The town developed around a crossing point on the Little Ouse, which eventually flows down into the Great Ouse.

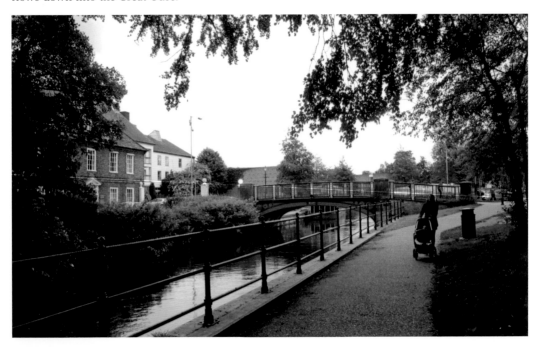

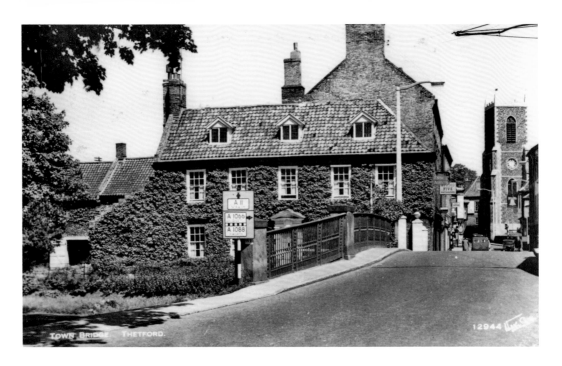

Town Bridge, Thetford, *c.* 1960

This bridge over the Little Ouse leads into the bustling old town. The ancient St Peter's church can be seen. It dates from between the fourteenth and fifteenth century, while the tower was rebuilt in 1785. Known as the 'black church', because of the amount of local flint used in dressing the building, it was renovated and refurbished by the town council in 2014 as a new community facility. Thetford is a busy market town and has much to offer visitors.

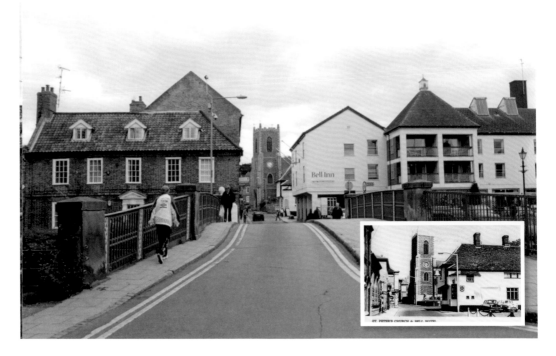

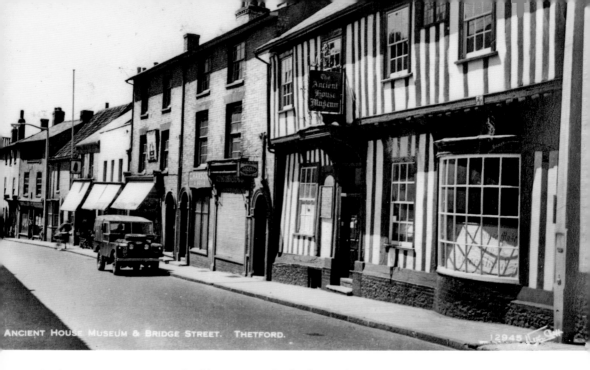

ANCIENT HOUSE MUSEUM & BRIDGE STREET. THETFORD. 12945

Ancient House Museum and Bridge Street, Thetford, c. 1960
The Tudor merchant's house, now the Ancient House Museum, is part of Thetford's fascinating history and helps to interpret its story for visitors. It has recently undergone a major renovation. Thomas Paine (1737–1809), the political activist and revolutionary, was born in Thetford and there is a statue of him in King's Street. There is also a more modern statue of Captain Mainwaring, from the popular television series *Dad's Army*, which was filmed nearby. There is also a small museum devoted to the programme.

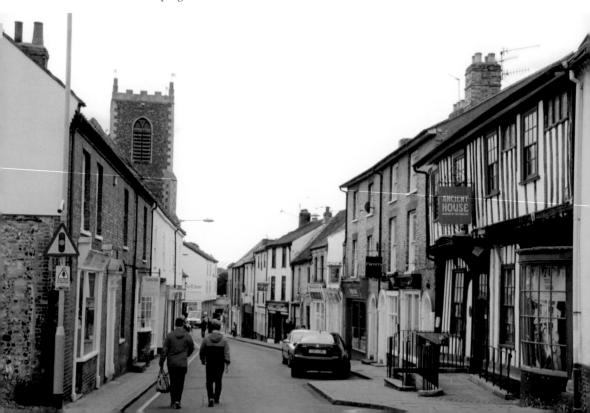

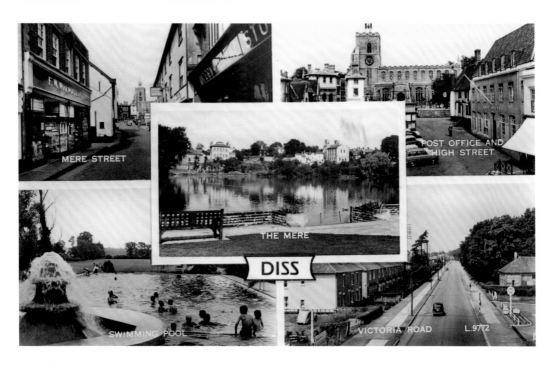

Diss, c. 1960

Diss sits right on the Suffolk border in the Waveney Valley. This small market town, with a population of some 7,500, is at the start of the Boudicca Walk to Norwich. Its most remarkable feature is the Mere, which covers some 6 acres and is naturally fed by several springs and is very deep. It is one of the attractive features of the town, with its nearby park and play area. There is a 'snail trail' here, which is appropriate for Diss.

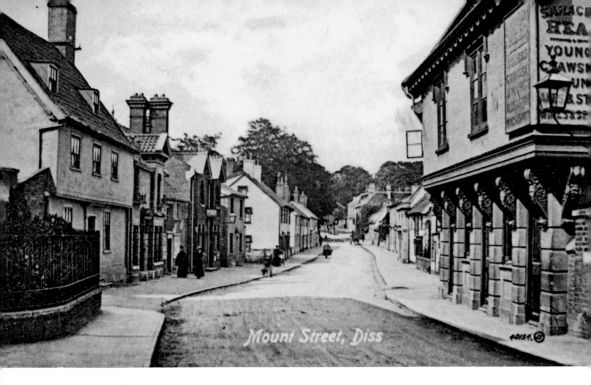

Mount Street, Diss, *c.* 1920

A view that has changed little over the years. The Saracen's Head can be traced back to the sixteenth century. Diss is full of fascinating old buildings, especially around the marketplace. The town has joined the Cittaslow movement, which translates as 'slow town', preferring to try and reduce the pace of life. Such a concept certainly suits this small, historic market town.

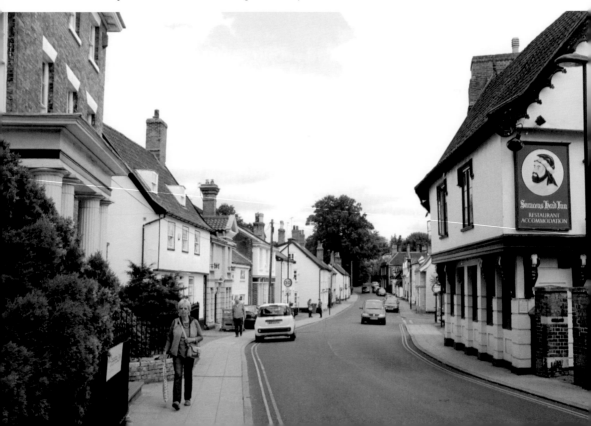

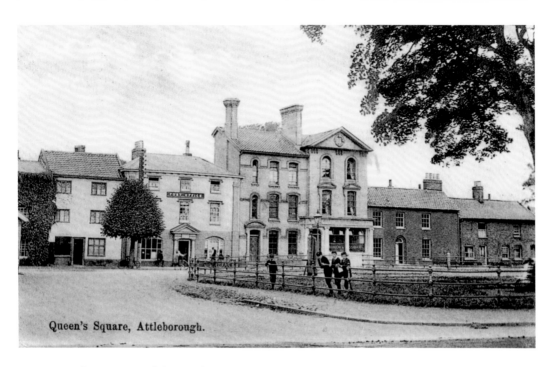

Queen's Square, Attleborough.

Queen's Square, Attleborough, c. 1914

The small market town of Attleborough is now bypassed by the A11 between Thetford and Norwich. The charming Queen's Square was once known as Market Hill, and about a decade ago the Thursday market moved back there. While Barclays Bank remains in the same imposing building, the post office is now the town hall and tourist information centre. A pump on the left of the green was erected to commemorate Queen Victoria's Diamond Jubilee, and restored in 2002 to mark Queen Elizabeth II's Golden Jubilee.

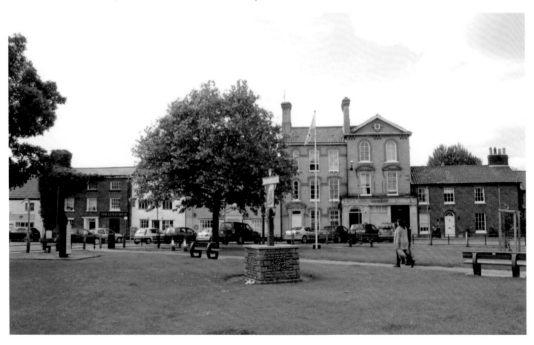

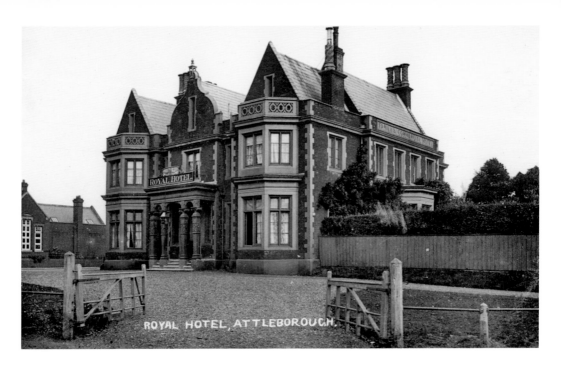

The Royal Hotel, Attleborough, *c.* 1920

The Victorian Royal Hotel, built on Station Road, was originally the New Inn, eventually taking the name of the Royal Hotel around 1888. This name apparently came about following a visit from the Duke of Connaught, one of Queen Victoria's sons. There is a Connaught Road nearby. In recent years it has become The Mulberry Tree. On the small traffic island opposite there is a milestone obelisk commemorating the Peace of 1856, which followed the Crimean War. It is engraved with names of battles: Alma, Sebastopol, Balaclava and Inkerman.

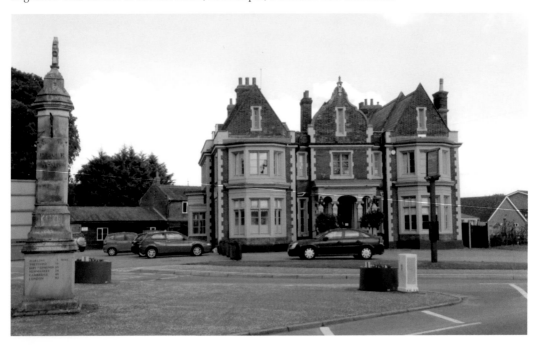

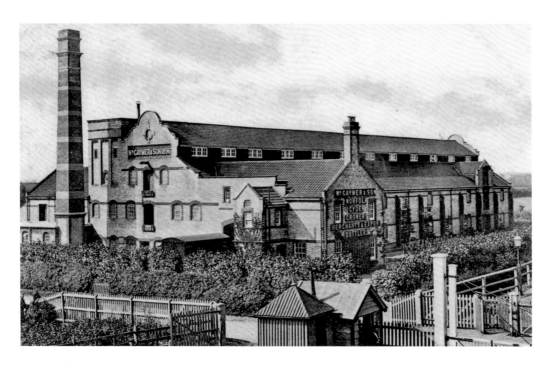

Attleborough, Messrs Gaymer & Sons, Cyder Works, c. 1905

Gaymers had been making cider in the area for over 100 years before moving in 1896 to the new factory right next to the railway, where it could have its own siding. In the first half of the twentieth century, Gaymers were the biggest employer in the town. The family-run firm was bought by Showerings of Shepton Mallet in 1961 and eventually the Attleborough factory was closed in 1995. Gaymers cider is now made in Somerset, and after different uses it now appears that the former site is being redeveloped.

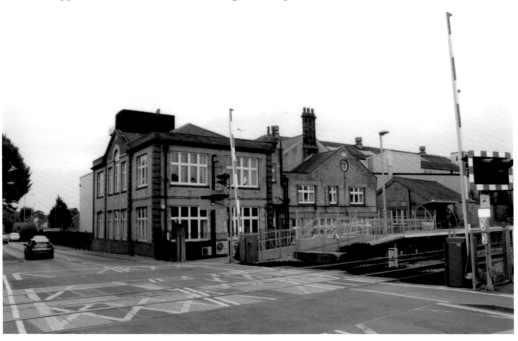

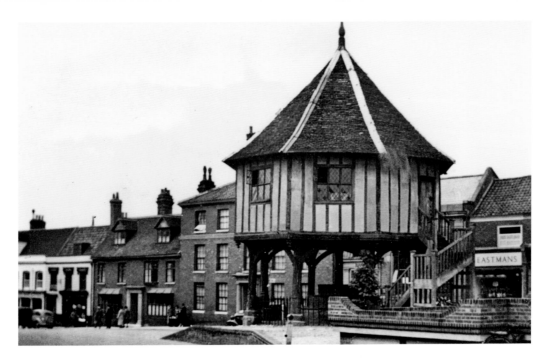

Market Cross, Wymondham

Another bypassed town on the A11, Wymondham, was the centre of Kett's Rebellion in 1549. The town's wealth was based on the woollen industry, like so many Norfolk and Suffolk towns. In 1615, a great fire swept through the mostly thatched buildings. As the town grew again from the ashes, this splendid market cross was built in 1617. As it was used to store valuable documents, it was built on stilts to protect them from floods and vermin. Today the market cross is used as the tourist information centre for an attractive, growing market town.

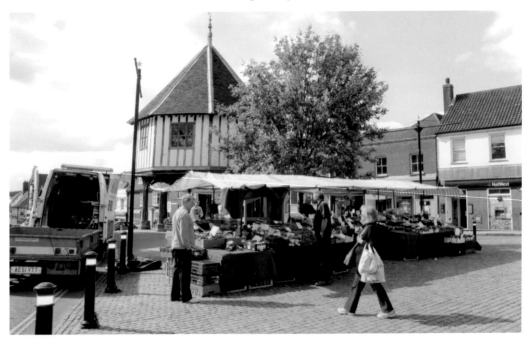

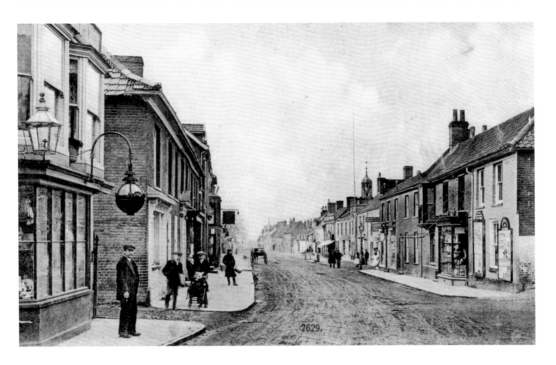

High Street, Watton, c. 1905

Watton is a smaller market town on the crossroads between Thetford to Dereham, and Brandon to Norwich. Like Wymondham, it too suffered a disastrous fire in 1674. As a consequence, Christopher Hey, a wealthy merchant, built the unusual clock tower on the high street in 1679. It has a bell tower to serve as a warning bell to sound in the event of similar disasters. The clock was given a new face in 1935 to mark the Jubilee of George V and Queen Mary.

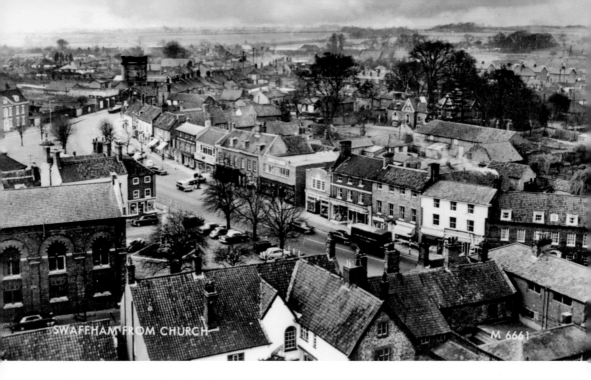

SWAFFHAM FROM CHURCH M 6661

Swaffham, Seen From the Church

Swaffham is a small, elegant market town, again built on the prosperity of the woollen industry. The village sign depicts the pedlar of Swaffham, from a well-known local folk tale, and was carved by local art teacher, Harry Carter, who created many of the village signs. He was a distant cousin of Howard Carter, the well-known Egyptologist and archaeologist. The town museum, the building with the flag in the photograph below, has an Egyptian room to mark this connection.

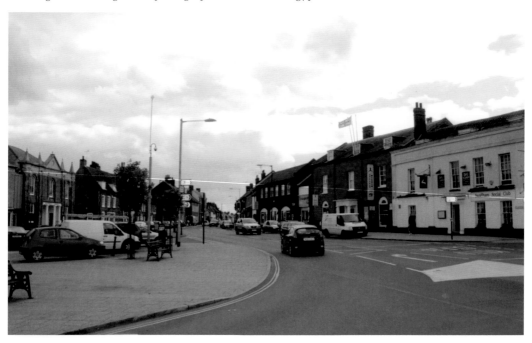

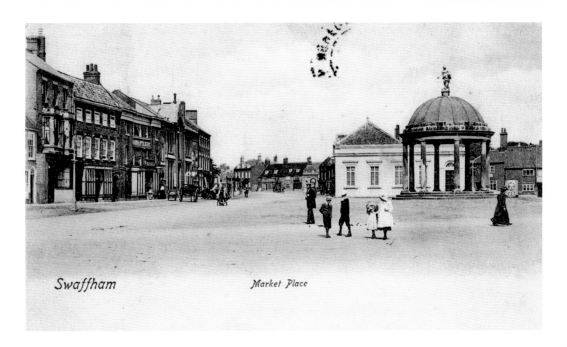

Swaffham *Market Place*

Swaffham Market Place, *c.* 1930

The market cross was presented to the town by George Walpole, 3rd Earl of Orford, in 1783. The figure on the top is Ceres, the Roman goddess of harvest. With its fine Georgian buildings, Swaffham was a fashionable town and reputedly one of Nelson's favourites. It was also 'Market Stepborough' in the television series *Kingdom* (2007–09), which starred Norfolk resident Stephen Fry. Today it is also well-known for the nearby Ecotech Centre, where huge turbines harvest wind power.

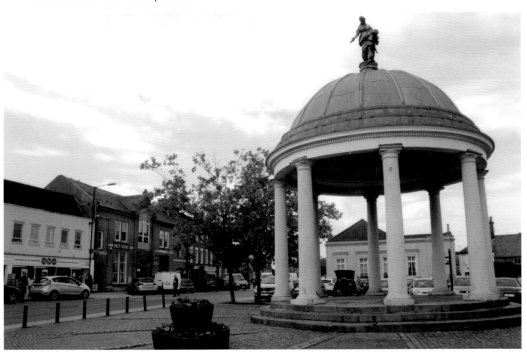

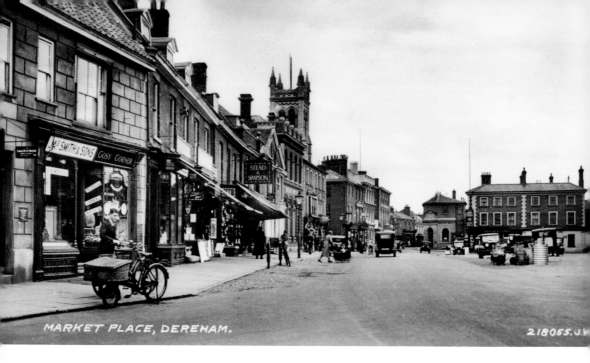

MARKET PLACE, DEREHAM. 218055.J.V

Market Place, Dereham

Dereham considers itself the 'Heart of Norfolk', as it is calculated to be the most central town in the county. Originally, it was East Dereham, as there is a West Dereham several miles away, but it is commonly known as Dereham today. Like other towns, it too had devastating fires: one in 1581 and another in 1659. The thirteenth-century church of St Nicholas survived to look down over the Tuesday and Thursday markets.

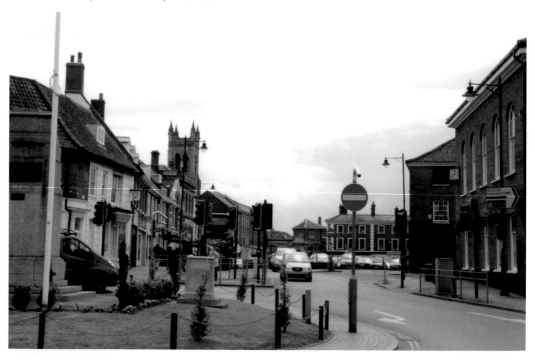

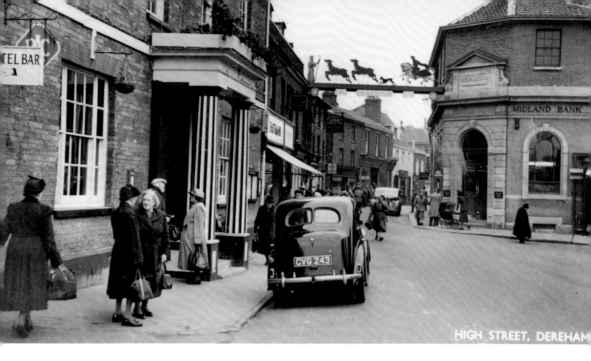

High Street, Dereham, *c.* 1960

Dereham claims the legend of St Wihtburh (sometimes Withburga), who founded a seventh-century monastery here and, like St Ethedreda at Ely, was one of the daughters of Anna, King of the Angles. Her body was subsequently stolen by the monks of Ely, and a holy well sprung up in its place. The sign that bridges the high street depicts the legend.

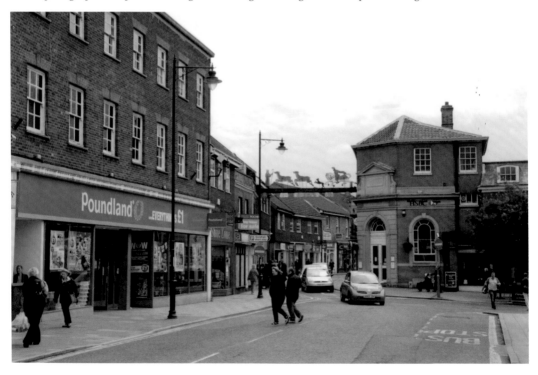

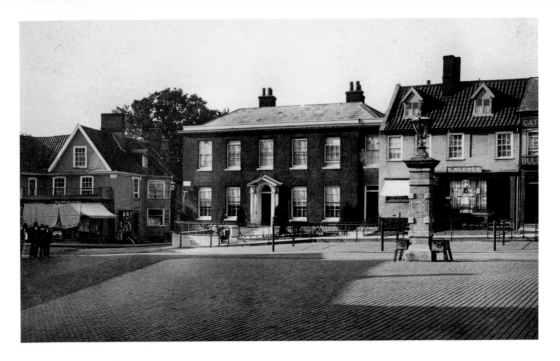

The Obelisk, Dereham, c. 1912

This fine mid-eighteenth-century obelisk, with a gas lamp added on top, was taken down and broken during the Second World War. This was because it was also a signpost, many of which were destroyed due to the fear of invasion. Few that were taken down elsewhere were as fine as this. The town's war memorial can be seen in a similar position. The photograph below shows the elegant assembly rooms built in 1756, which now house the Dereham Town Council.

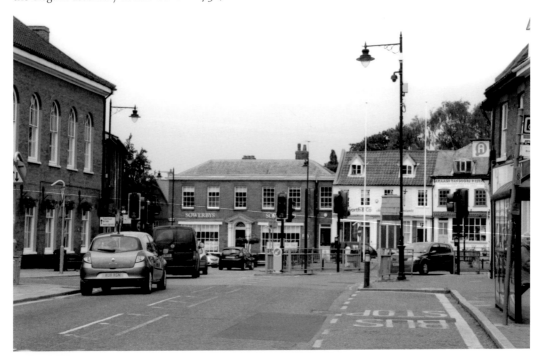

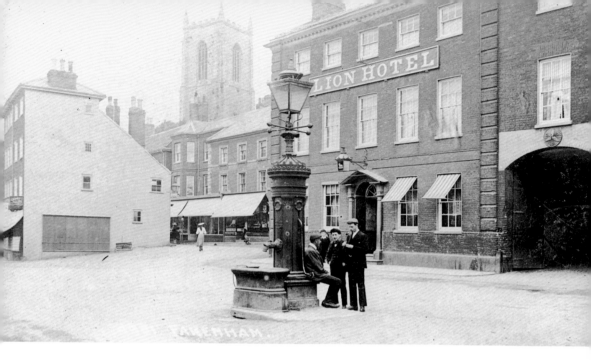

Fakenham, *c.* 1910

The seventeenth-century Lion Hotel, sometimes known as the Red Lion, was a once splendid coaching inn. It closed in 1974 and, after use as the town council offices from 1976 to 2000, it is now the Gallery Bistro. The wonderful town pump with the gas lamp on top has gone, although there is a similar structure with a lamp today. Sadly, a modern fire on Sunday 25 May destroyed old shops in front of the church, which explains the safety barriers when I was there. Many people visit Fakenham because of the nearby national hunt racecourse.

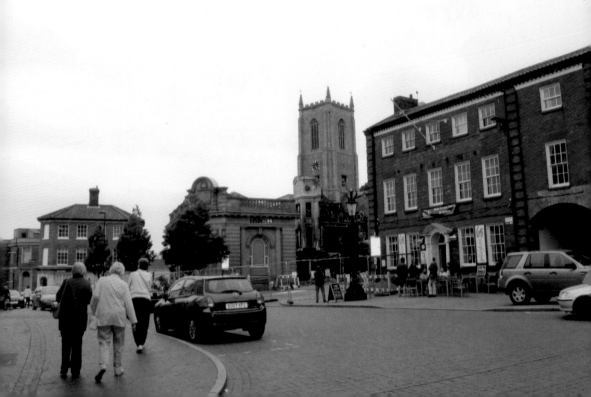

Village Pump, Walsingham, *c.* **1960**

Common Place, Walsingham, with its remarkable sixteenth-century octagonal pump house. The original pinnacle was broken off in 1900, and replaced by the iron brazier now used as a beacon. Walsingham is one of the best-known and most-visited centres of pilgrimage in the country, dating back to 1061 when the Lord of the Manor's widow had a vision of the Virgin Mary. Seldom will you find so many magnificent medieval timber-framed and grand Georgian buildings in such a small village.

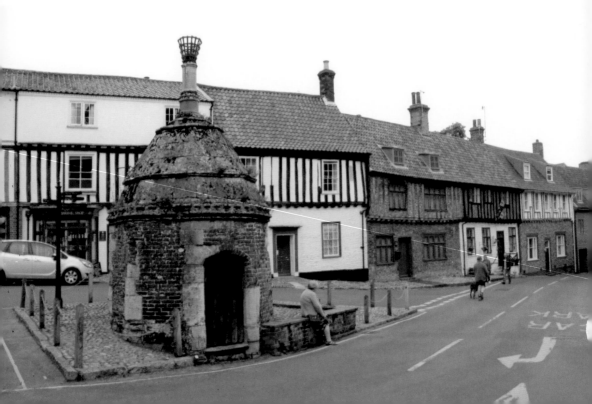

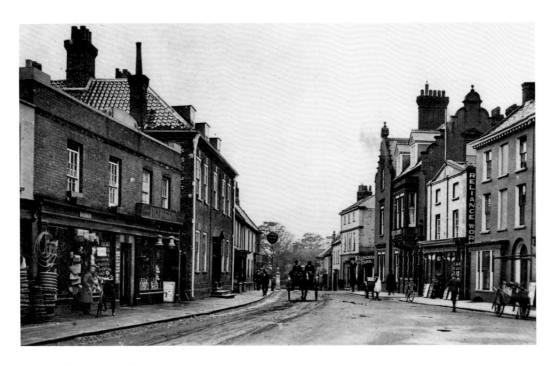

High Street, Holt, c. 1912

Holt is a small market town only 3 miles from the coast. At one time Cley was its port. The North Norfolk Railway, also known as 'The Poppy Line', runs between Holt and Sheringham, often with steam trains. Holt is very busy with tourists and holidaymakers from the nearby coast. Like many of the other market towns, Holt had a major fire. This was in 1708, and as a result the small town has many fine Georgian buildings.

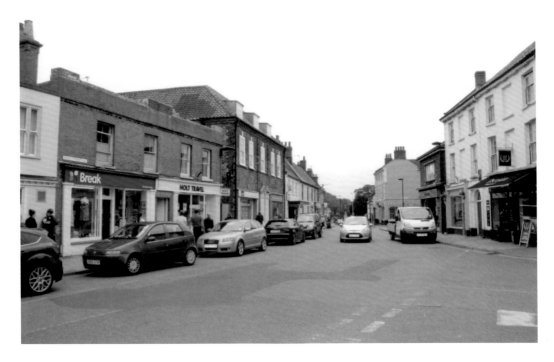

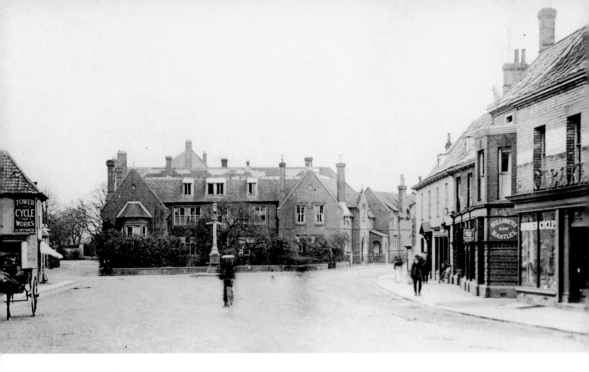

High Street, Holt, c. 1912

The war memorial stands in a street scene hardly changed over the past 100 years except, of course, from the cars. It is remarkable, not only for its elegance, but also the number of small independent shops and businesses in the town. I had a cousin who saw Holt from a different perspective, as he stayed for a long time in the 1920s while being treated for tubercolosis at the nearby Bramblewood Sanatorium. Holt is well known for its association with the Gresham's School, which Sir John Gresham founded in 1555.

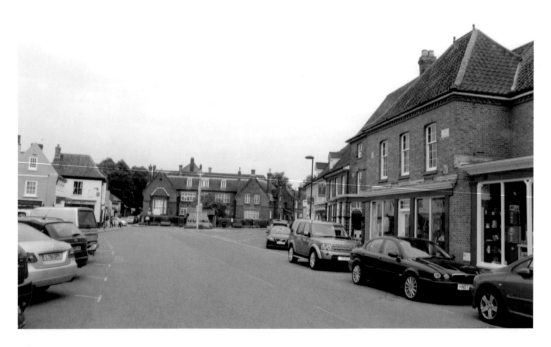

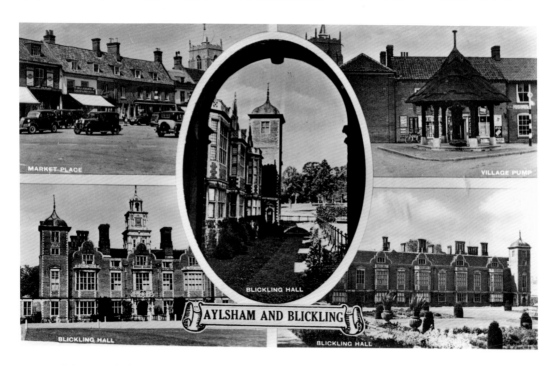

MARKET PLACE

VILLAGE PUMP

BLICKLING HALL

AYLSHAM AND BLICKLING

BLICKLING HALL

BLICKLING HALL

Aylsham and Blickling

Aylsham is another ancient settlement and small market town. The market charter was granted by Henry VIII in 1519. In the fourteenth century, John of Gaunt was Lord of the Manor. The popular Black Boys Inn has been on this site in the town centre since the 1650s. Blickling Hall is one of several fine stately homes in this part of Norfolk. Aylsham, like Diss on the other side of the county, is part of the Cittaslow movement.

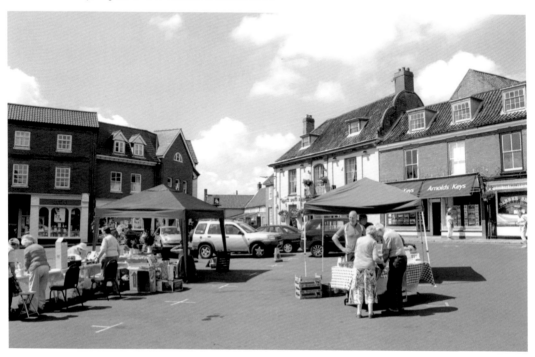

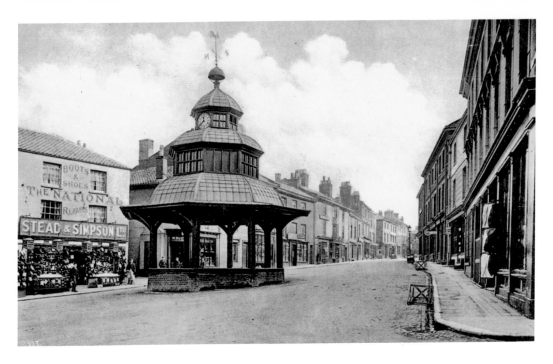

North Walsham, *c.* 1906

North Walsham owes its name to walsham, a lightweight cloth once manufactured here, along with worsted cloth in the nearby village, when Flemish weavers settled in the area in the twelfth century. The market cross was built between 1550 and 1555, but lost in a great fire in 1600. Bishop Redman was responsible for its replacement in 1612. It was extensively refurbished in 1984. Horatio Nelson had his schooling at Paston Grammar school here, before joining the Navy at the age of twelve.

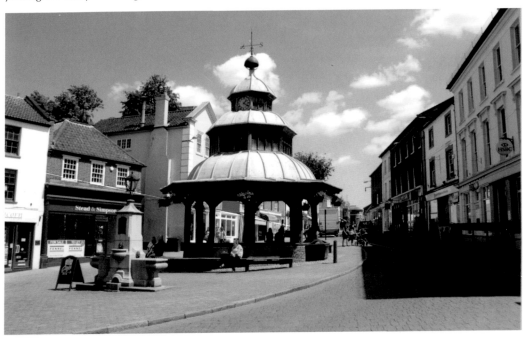

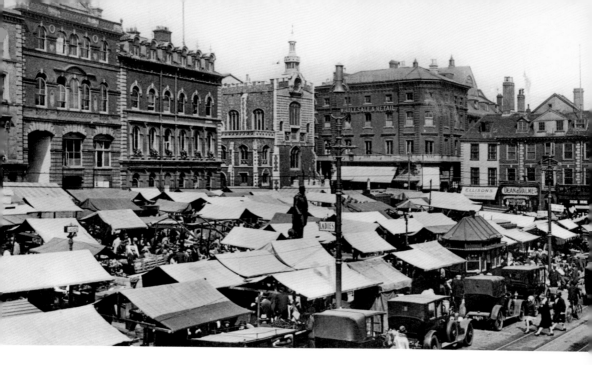

Market Place, Norwich, c. 1930

'Norwich, a Fine City,' and indeed it is. This is the major city in the county, and its administrative centre. The market here dates from Norman times. In 1938, the old municipal buildings alongside the marketplace, seen above, were replaced with the City Hall and its impressive landmark clock tower standing at 185 feet. With its cathedral, shops, restaurants, theatres and cinema, Norwich has something for everyone.

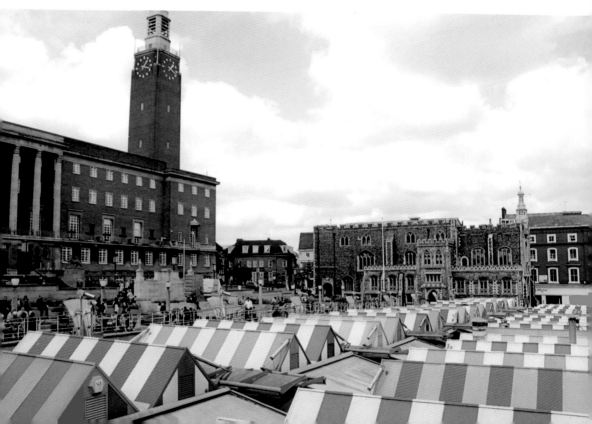

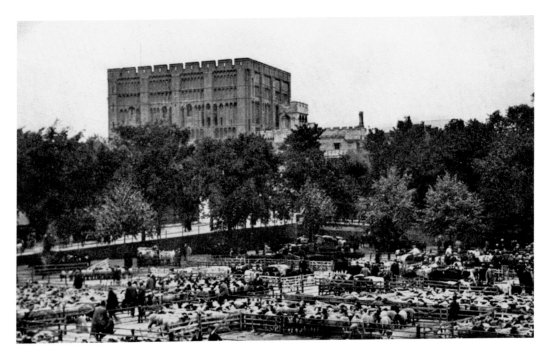

Cattle Market & Castle, Norwich, *c.* 1912

Norwich Castle was built as a royal palace between 1067 and 1075 by William I, to demonstrate his authority as the new king after the invasion of 1066. The keep was added in the twelfth century, and in the fourteenth century it became the city gaol for the next 500 years. It is now a magnificent museum, well known for its collection of paintings by artists of the Norwich School. For some 300 years, the old cattle market was held here, until moving to new premises in 1960. There is a large underground car park on the site today.

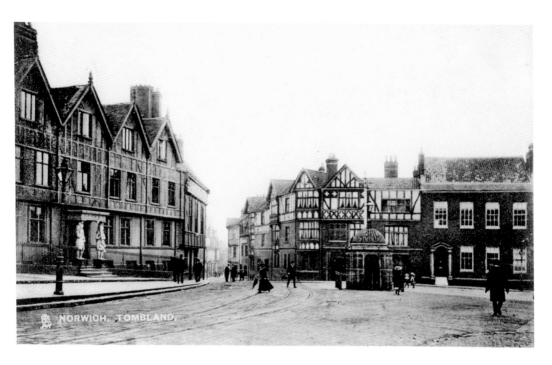

Norwich, Tombland, *c.* 1904

This is a charming area of small shops and restaurants. Norwich was formed from three earlier Saxon and Danish settlements at the river crossing on the Wensum. Tombland is sited on one of the original areas, the name meaning empty or vacant space. This was the site of the Saxon market and the oldest area of the city, close to the cathedral. There is a memorial to Nurse Edith Cavell (1865–1915) who was born at Swardeston, near Norwich, and, after her execution and burial in Belgium, was later reburied in Norwich.

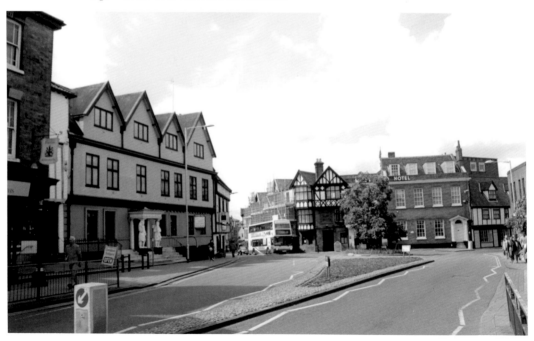

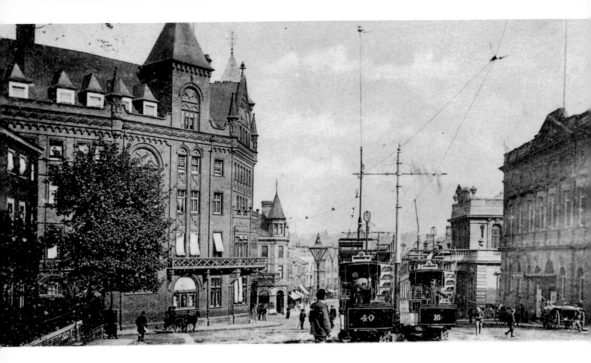

Royal Hotel and Post Office, Norwich, *c.* 1905

The Royal Hotel was designed by Edward Boardman on the site of a former coaching inn, and opened in 1897. Boardman served as mayor of Norwich from 1905/06. It closed as a hotel in 1977 and today has various uses. The building opposite is the old Agricultural Hall, which opened as an exhibition hall in 1882 and became Anglia TV studios in 1959. The post office beyond it was built as the Crown Bank in 1866, and served as the head post office from 1875–1969. After a period as part of Anglia TV, it is now offices.

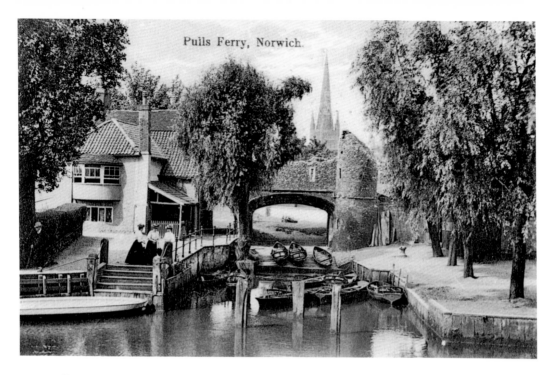

Pulls Ferry, Norwich.

Pulls Ferry, Norwich, *c. 1910*

This was the watergate, with a waterway to the Cathedral Close, when stone was brought by sea and river from France for the building of the Norman cathedral. The ferry buildings date from the fifteenth century, and take their name from John Pull, who operated the ferry across the Wensum from 1796–1841. The ferry ceased operation in 1943, and the buildings were restored in 1948/49.

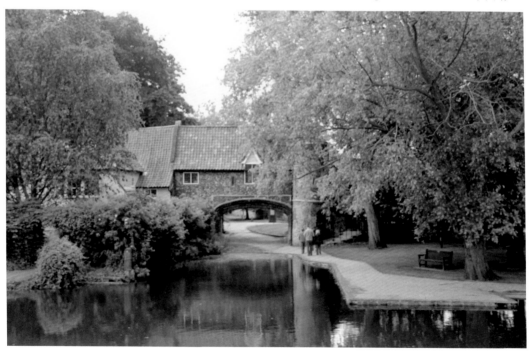

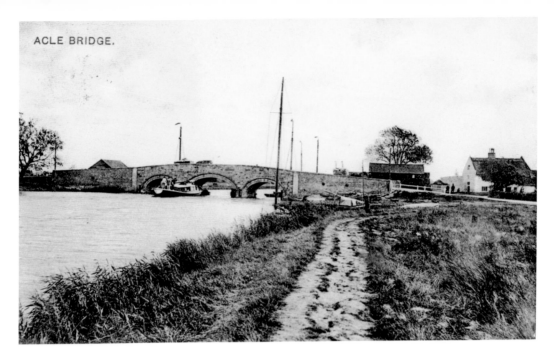

ACLE BRIDGE.

Acle Bridge, Acle, c. 1909
Acle is a small market town on the River Bure, but in earlier times was an important port. For most motorists it is the start of the Acle Straight, opened in 1935, halfway between Norwich and Great Yarmouth. In 1989, a new dual carriageway section of the A47 bypassed the village. This view is of the old bridge, about a mile from the village on the old Yarmouth road. It was replaced in 1931 by the bridge seen below. It is the only bridge across the River Bure between Great Yarmouth and Wroxham.

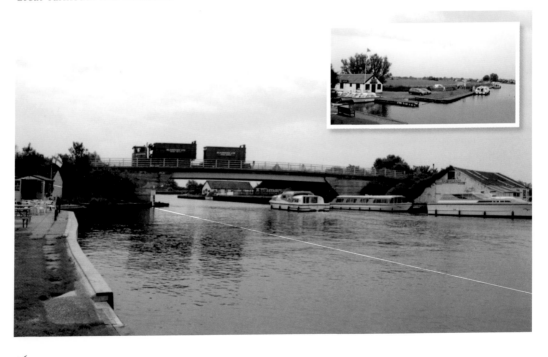

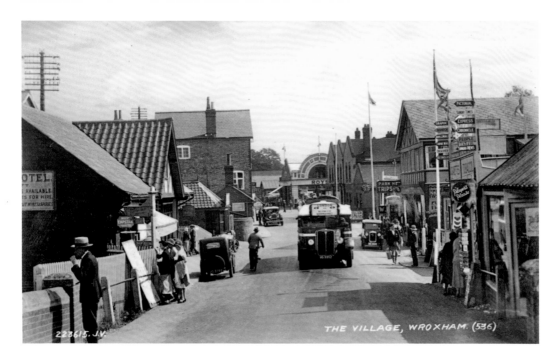

THE VILLAGE, WROXHAM. (536)

Wroxham, c. 1935

Wroxham is synonymous with the name of Roy's, the family business that developed Wroxham into what became known in the 1920s and 1930s as the 'Capital of the Broads'. The brothers, Alfred and Arnold Roy, began the family business at Coltishall in 1895 but moved to Wroxham in 1899. It soon had shops and businesses to meet all the needs of holidaymakers and boat users. Roy's is still a family business today. The original food hall is now a McDonald's, while a new Roy's supermarket stands across the road.

Food Hall

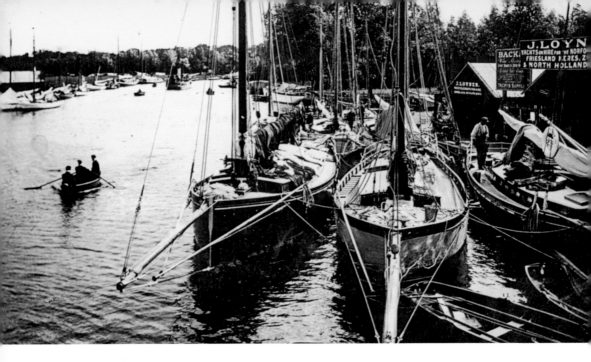

From Wroxham Bridge, c. 1910

The Broads are an area of rivers – principally the Yare, Bure, Ant and Thurne and large lakes – many of them old peat digging areas, known as turbaries, that became flooded. New waterways were often then cut, linked together to make a vast network. Originally, these waterways were the haunt of wildfowlers and fishermen, like the fens. They were also used to transport goods and people around this corner of Norfolk. In the early seventeenth century, the Norfolk wherry, a trading vessel designed for these waters, was developed.

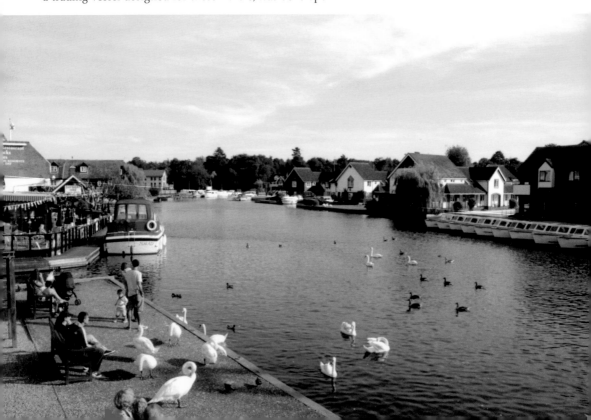

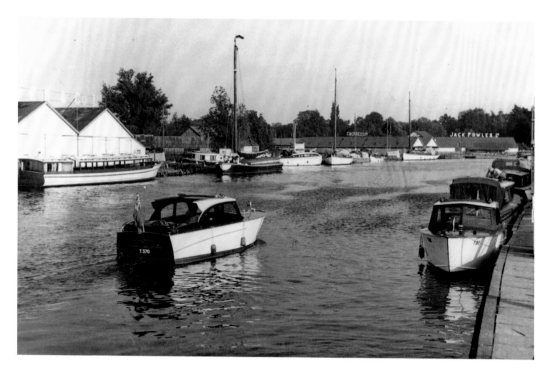

From Wroxham Bridge, c. 1960

By around 1884, John Loynes had built a boathouse at Wroxham. Originally with a yard on the Wensum at Norwich, John Loynes was a boat-builder who realised the growing popularity of these waterways for pleasure in Victorian times. In 1882, he published one of the first guides to boating on the Broads. In the 1890s, the Great Eastern Railway promoted the Broads and its links to the area.

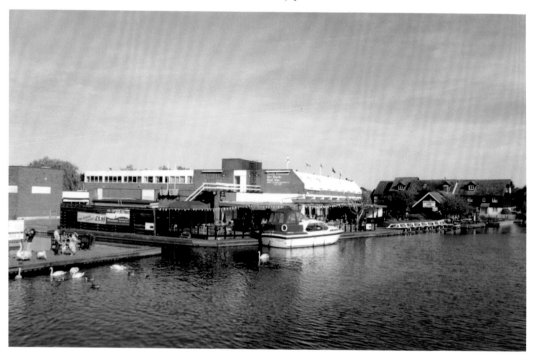

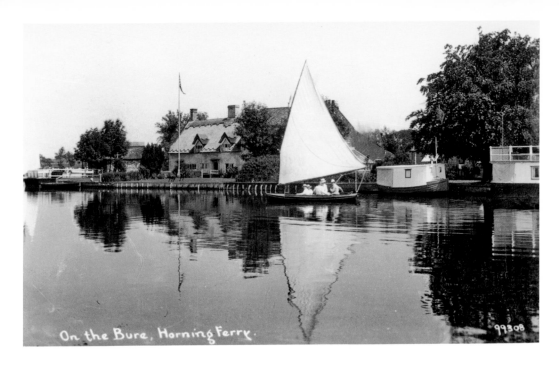

On the Bure, Horning Ferry, c. 1935
The ancient Ferry Inn at Horning has had an eventful, and at times tragic, history. It was almost destroyed by a lone German bomber on the night of 26 April 1941, when twenty-one of the twenty-four people inside were killed. It was rebuilt, but suffered from a fire in the mid-1960s. After a closure, it reopened in 2010 totally refurbished as a beautiful riverside inn and restaurant. There are also hopes to revive the centuries-old ferry across to the Bure Marshes.

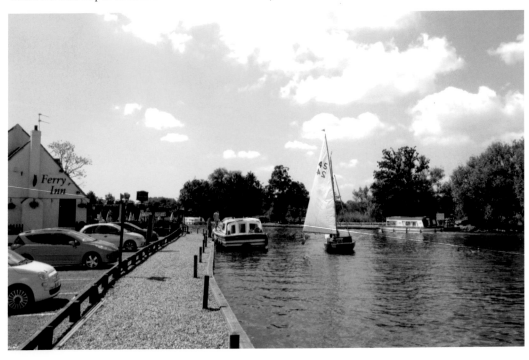

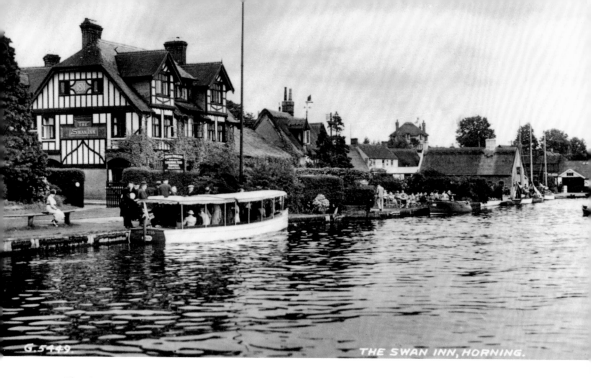

The Swan Inn, Horning

The Swan Inn, Horning

Horning is on the northern bank of the River Bure. The name means 'folks who live on the higher ground between the rivers'. The picturesque Swan at Horning was built on the site of an old cottage early in the nineteenth century. It is the home today of the Southern Comfort, a Mississippi paddle boat, specially built for cruising on the Broads with a capacity for 100 passengers.

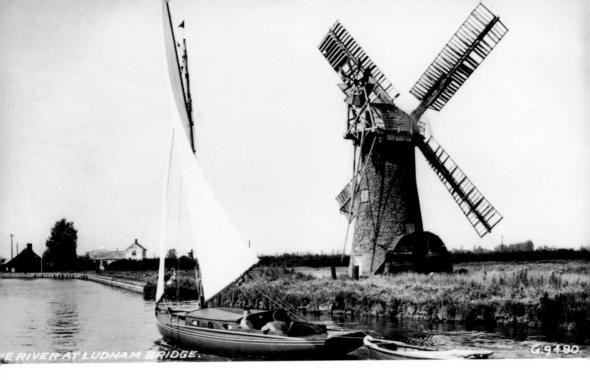

THE RIVER AT LUDHAM BRIDGE. G.9480.

The River at Ludham Bridge

Ludham Bridge takes the A1062 across the River Ant, which flows into the River Bure. Sadly, the old drainage mill is now a ruin, with just parts of the brick tower visible among the bushes. There are shops and a café here. The moorings are busy, with Wroxham and Horning nearby on the Bure, and Potter Heigham downstream.

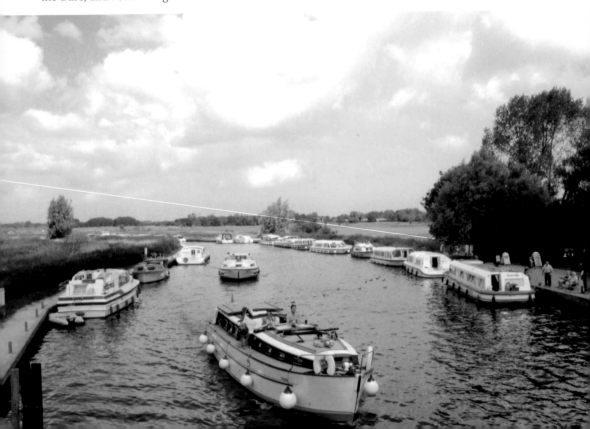

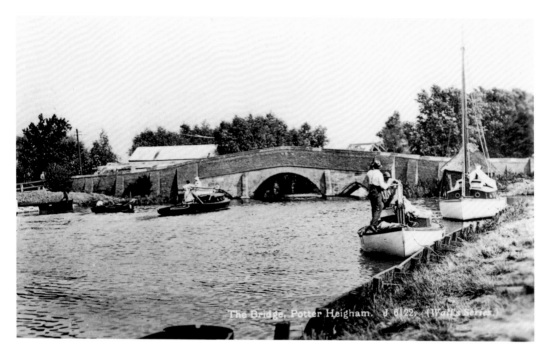

The Bridge, Potter Heigham. *J 6/22. (Wall's Series)*

The Bridge, Potter Heigham, *c.* 1925

Potter Heigham is on the River Thurne. The area next to the medieval bridge, dating from around 1385, is a hub for boat-users and tourists, with Latham's store and places to eat. The bridge is notoriously difficult to navigate and there is a pilot, the office can be seen below, to guide river users through to Hickling Broad, Martham Broad and Horsey Mere upstream. The main road, the A149, is now carried across the river by a modern bridge.

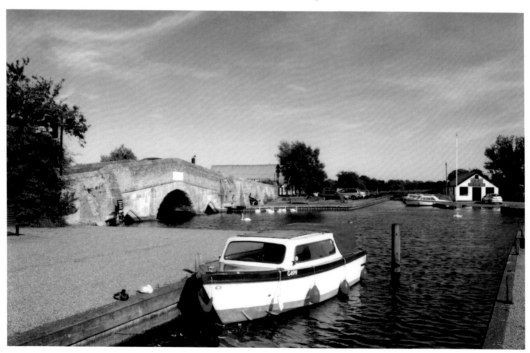

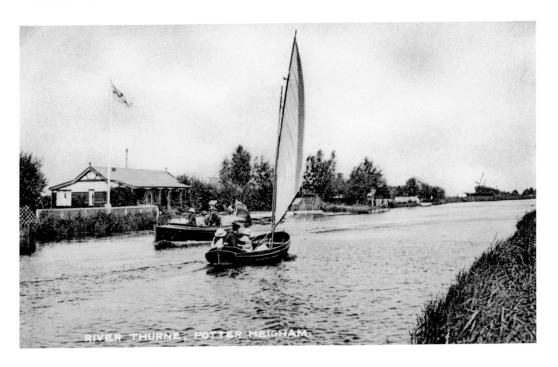

River Thurne, Potter Heigham

The Broads National Park is a haven for wildlife. There are numerous trails, paths and cycleways through the area, so you don't have to hire a boat to be able to enjoy the Broads. It is fascinating to think how this old manmade industrial area, where peat turves were dug in vast quantities for fuel – as there is no local coal – has been managed and changed in less than 100 years to become the wonderful recreational area it is today.

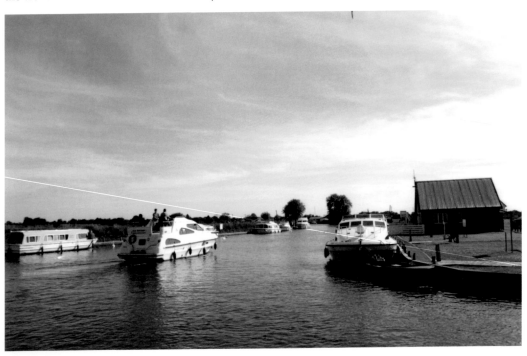

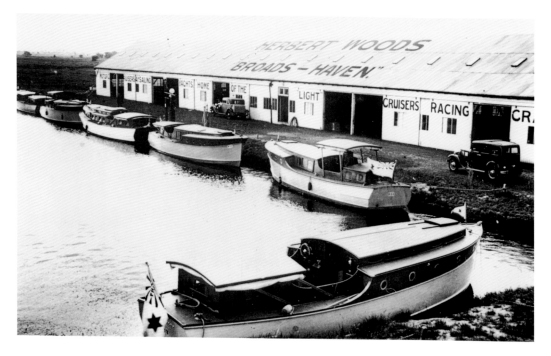

A Few Light Cruisers and Garage, Broadshaven, c. 1936
Herbert Woods is a name synonymous with Potter Heigham. He took over the family business in 1926 and began to develop it. In 1931, he built Broads Haven, the first yacht marina on the Broads. As a boat designer, he was well known for the 'Lady' fleet of yachts and the 'Light' fleet of motor yachts seen here. The massive buildings seen today are testament to his legacy, and the company runs 140 cruisers for hire, making it the second-largest hire boat company on the Broads.

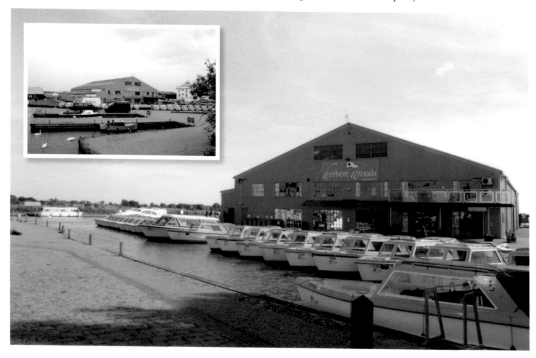

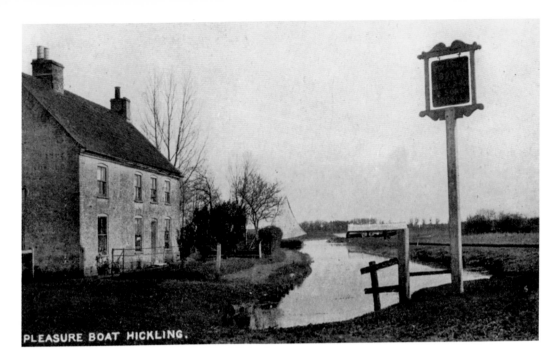

PLEASURE BOAT HICKLING.

The Pleasure Boat, Hickling

The Pleasure Boat has a long history going back perhaps to the seventeenth century. In 2010, it reopened as a free house, with new owners after a period of closure. Hickling Broad, the largest of the Broads, was the setting for a lovely 1950s film *Conflict of Wings*, which starred Muriel Pavlow and John Gregson. Even the Pleasure Boat was featured. Managed by the Norfolk Wildlife Trust, Hickling Broad is a nationally important Ramsar site, and guided boat trips can be booked at the Pleasure Boat dyke.

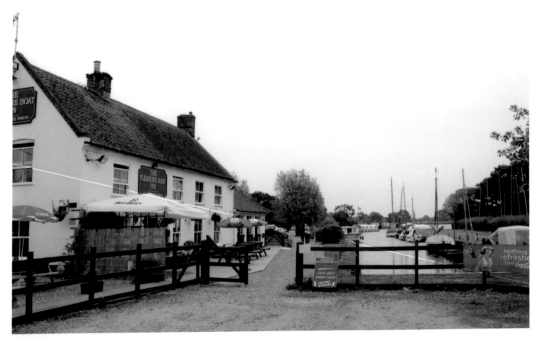

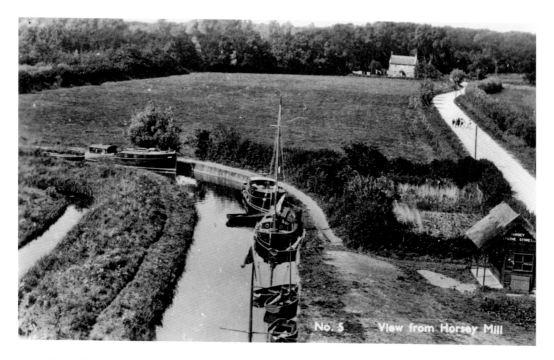

No. 5 View from Horsey Mill

View from Horsey Mill

Horsey Mere and Waxham New Cut mark the end of navigation on this part of the Broads. Horsey Mill, owned by the National Trust, is a short distance from the coast, and the B1159 winds past it between Sea Palling and Winterton. The Mill was built in 1912, on the foundations of an earlier drainage mill. The windpump operated until 1943 as one of many, lifting water from the dykes draining the low-lying marshes into the Broads and from there to the sea. It provides a fascinating history of drainage, and a great view.

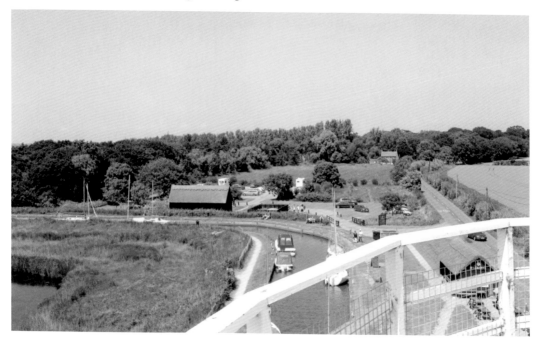

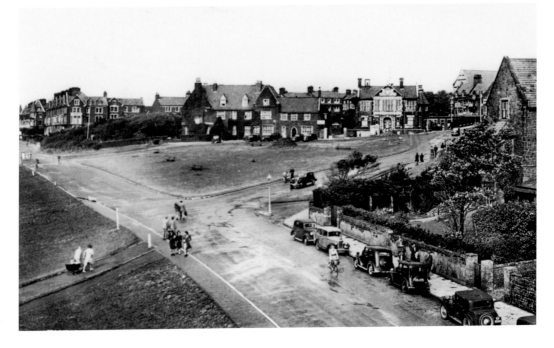

Hunstanton, c. 1948

Henry L'Estrange Styleman le Strange (1815–1862) lived at nearby Hunstanton Hall and had a vision of a new seaside resort alongside the Wash between Old Hunstanton and Heacham. His central feature was to be a triangular green with the sea as its base. In 1847, he began with the Golden Lion, seen in the centre with the town hall next to it. The resort didn't prosper at first, but after his death his son, Hamon le Strange, carried on Henry's work just as the new railway arrived in 1862.

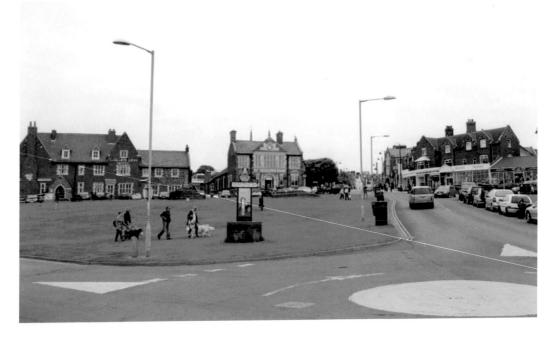

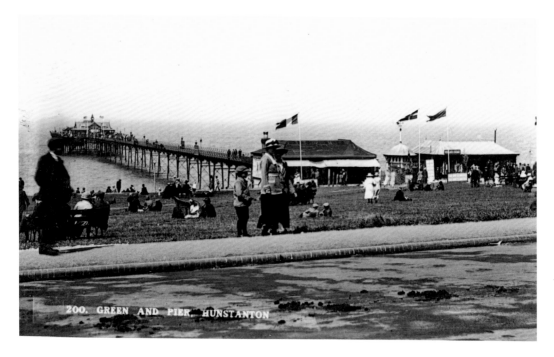

200. GREEN AND PIER, HUNSTANTON

Green and Pier, Hunstanton

Hamon le Strange brought the old village cross from Snettisham as a feature for the green, and the railway brought in the people. The splendid Sandringham Hotel was built next to the end of the railway line, and New Hunstanton, as it was known, began to realise the original vision. In 1870, an elegant pier stretched out from the base of the green and paddle steamers brought even more visitors. Sadly, the pier was lost in a storm in 1978. The railway had already closed in 1969 and the Sandringham was demolished, but the town remains very popular with holidaymakers.

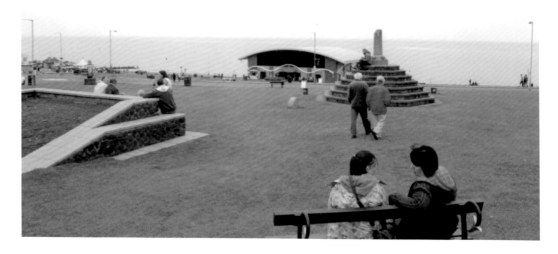

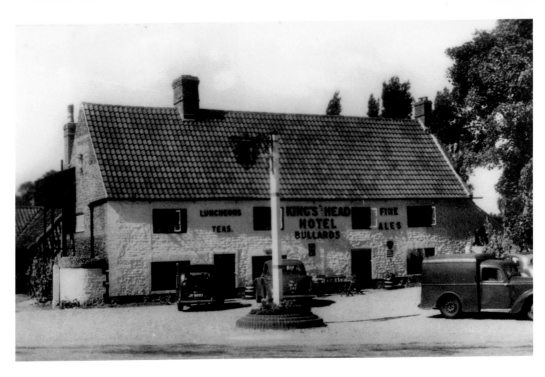

The King's Head, Thornham, c. 1960
A popular public house since the mid-seventeenth century, the King's Head stands beside the main road from Old Hunstanton. For the last ten years it has been known as The Orange Tree and is a restaurant with many awards.

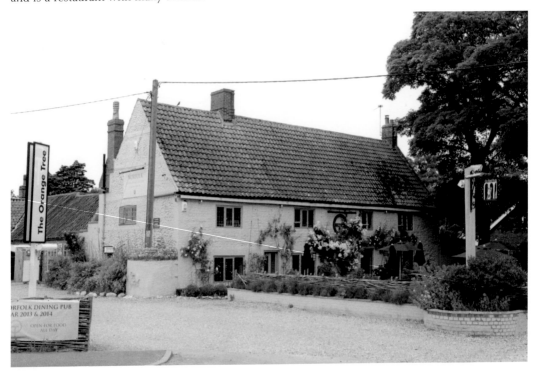

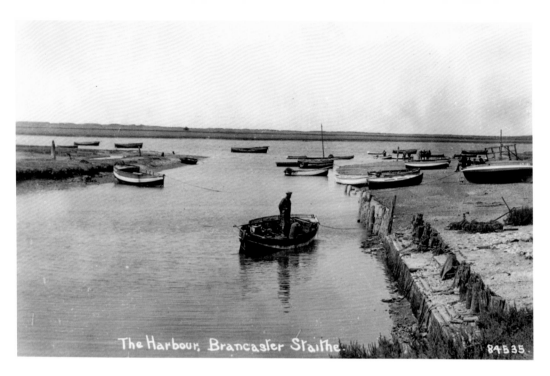

The Harbour, Brancaster Staithe

The Harbour, Brancaster Staithe

Brancaster Staithe – *staithe* is from the Norse word meaning 'landing stage' – was once a more important port and local smuggling haunt. Trips go from here to Scolt Head, to see the wildlife, and it is a popular sailing spot. When the tide is out the water in the inlet is shallow enough to wade across to the sandbanks, but this is not a place to be foolhardy, as the tide can come in very quickly.

High Tide, Overy Staithe

The great English hero Horatio Nelson (1758–1805), was born at nearby Burnham Thorpe, where his father was the rector. Burnham Overy Staithe is where he got his first experience of the sea, learning to row and sail here when he was ten. Edged by cottages and an art gallery, this is a lovely spot where freshly caught fish and crabs can be bought at the harbour. Once a more important port, the silting-up exposes acres of mud at low tide, but this is now a busy sailing harbour.

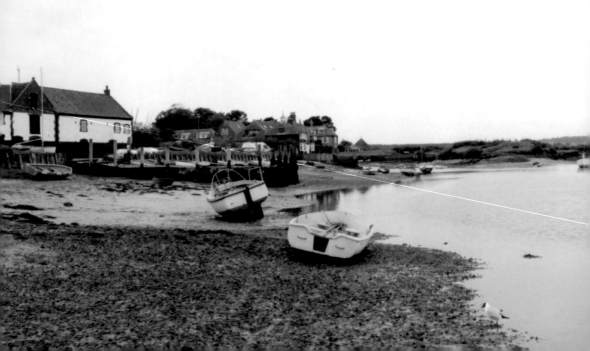

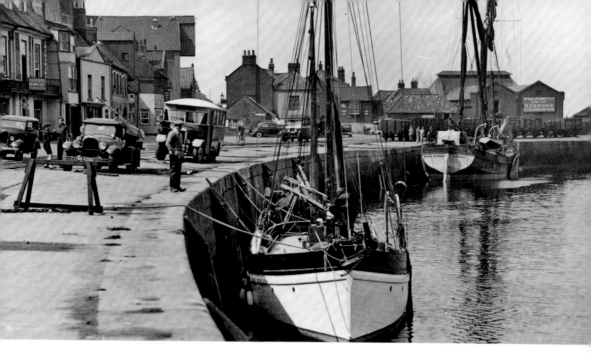

The Quay, Wells

This was one of England's major ports in Tudor times, when East Anglia was one of the wealthiest parts of the country. The quay was completed in 1853 and was busy importing coal and exporting locally grown produce. As with other Norfolk ports, silting up was always a problem and even the coming of the railway in 1857 failed to save the commercial life of the town. But with the wonderful beaches nearby on the Holkham estate, Wells grew in the twentieth century as a popular destination for trippers and holidaymakers.

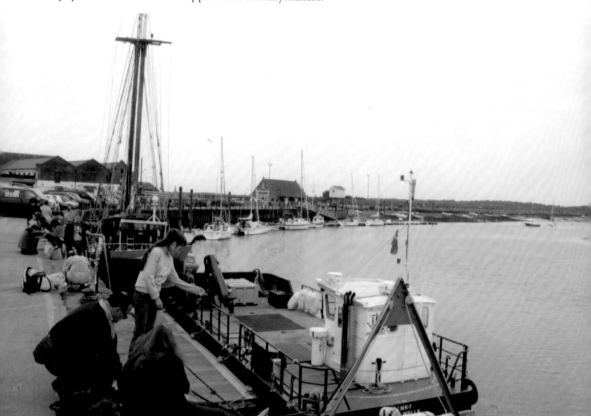

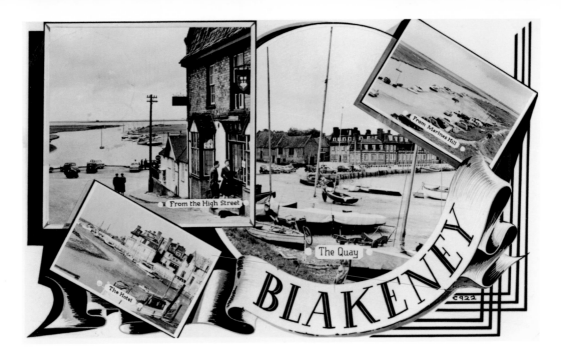

Blakeney

One of the Glaven ports with Cley and Wiveton, Blakeney declined because of silting-up, but found new commercial life through the growth of the holiday industry. The imposing Blakeney Hotel, opened in 1923, stands on the site of the old Crown and Anchor Inn, which was frequented by smugglers. Historic, colourful and popular with leisure sailors and wonderful for walkers, Blakeney is a gem on the North Norfolk Heritage Coast.

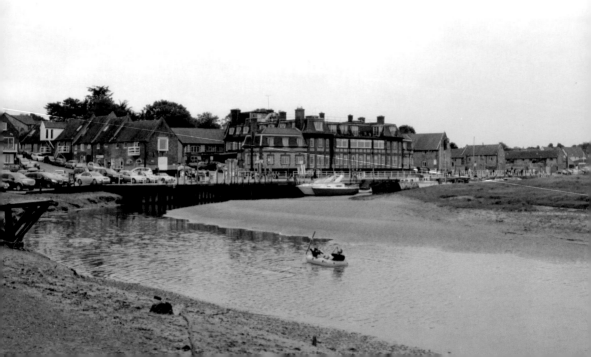

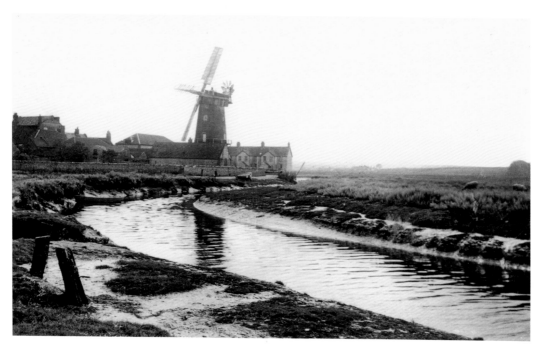

Cley

The picturesque eighteenth-century tower mill was restored in 1920, and the little former port is always busy with visitors as cars squeeze through the narrow main street. In the seventeenth century, Sir Henry Calthorpe put a dam across the Glaven, enclosing and draining the marshes for agricultural use. What is now the Norfolk Wildlife Trust began at the ancient George Hotel in the village, in 1926, and this whole stretch of the coast is a haven for ornithologists.

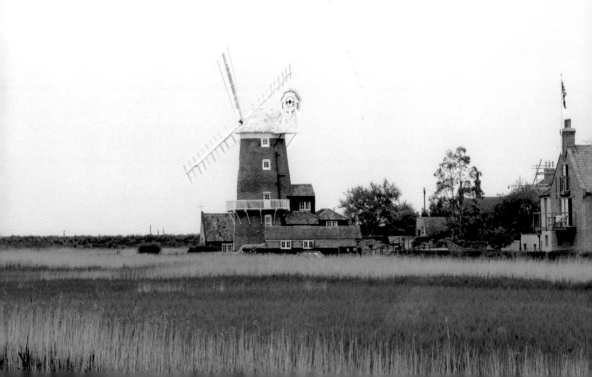

Marshes and Rocket House, Salthouse

The reclaimed salt marshes here are seriously threatened by the changing climate and the rising sea levels. They are protected from the sea by shingle banks, which have been raised higher and higher over the years. Hit badly in 1953 by the Great Storm, the coast here was very seriously affected by the storms and tidal surge in December 2013. The raised shingle banks were pushed further inland by the force of the sea, and it is possible that much of the marshes will eventually be surrendered to the sea.

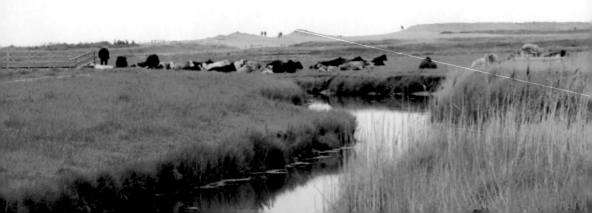

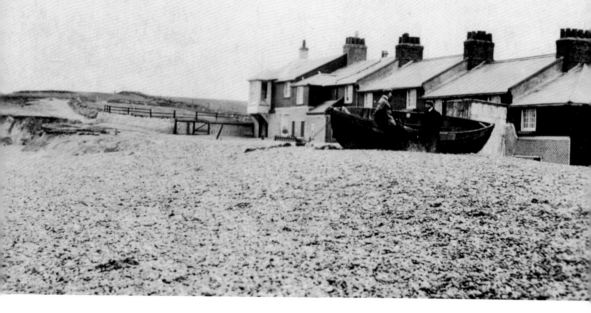

The Old Coastguard Station, Weybourne
Here the shingle spit of Blakeney Point meets the cliffs, at what has always been a significant point on the Norfolk coast. It was thought that any invasion of England might happen here during the time of the Armada and the Napoleonic Wars. During the two World Wars, the coast here was heavily defended. The old coastguard houses have long gone, and the sea pushes against the shingle banks and wears away the cliffs at what is a popular place for artists and those seeking somewhere quiet and more remote.

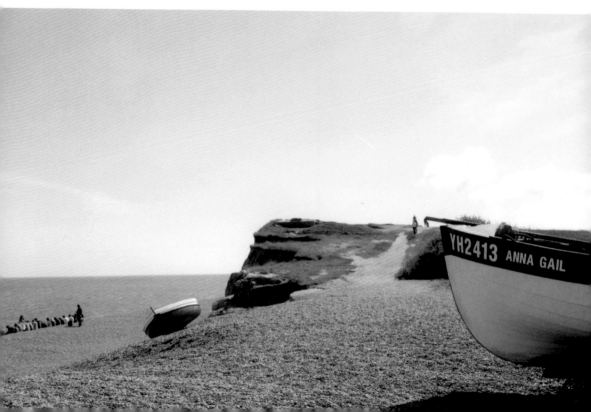

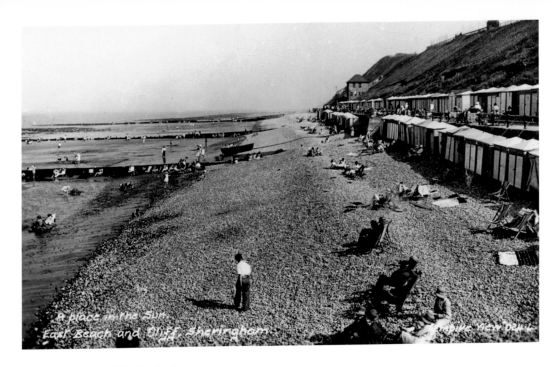

East Beach and Cliff, Sheringham, c. 1935

The old fishing port of Sheringham still has a small fishing fleet and now an offshore wind farm. Over the centuries, it has been heavily fortified against the sea, and the beach huts have moved up to line the promenade behind the sea wall. Some of the grand hotels have been lost, but the new lifeboat museum, with its observation tower, has opened in the last few years as an added attraction for the thousands of visitors and holidaymakers who flock here to Sheringham's crowded streets and Little Theatre.

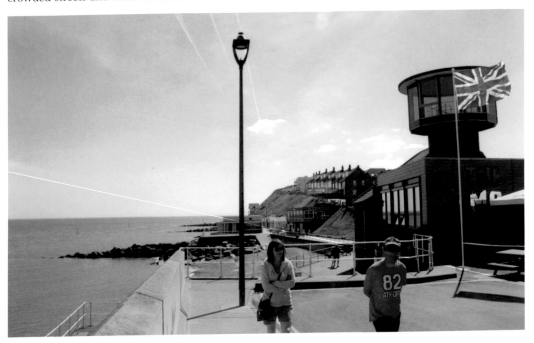

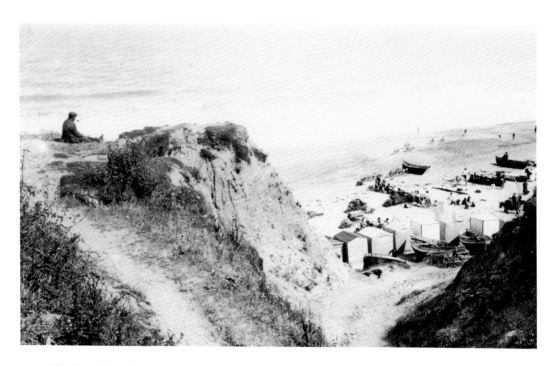

The Gap, East Runton, c. 1910

The ancient access to the beach for the local fishermen leads down to miles of beautiful sea-washed sands that won it a Seaside Award for 2014. There are many caravan sites along this stretch of coast. In Edwardian times, there were rows of beach huts along the sand at the foot of the cliffs, but as elsewhere, these have now all gone. This is a popular place for surfers and there is a poignant small memorial at the top of the gap to those who once rode the waves.

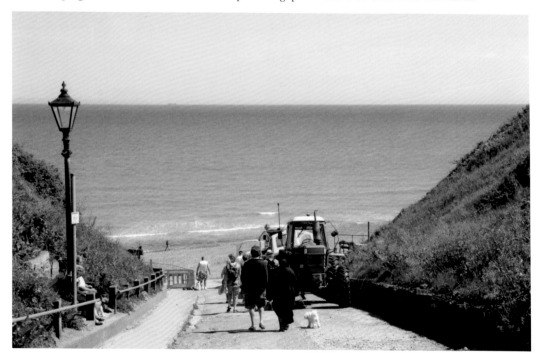

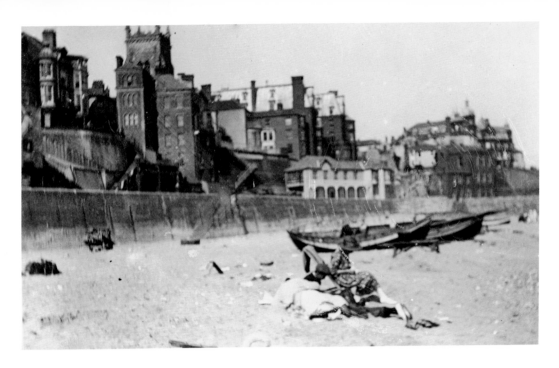

Cromer, c. 1910

For centuries the sea claimed parts of the old town, until the mid-nineteenth century, when massive sea walls and a new promenade were built. Cromer now rises dramatically behind these defences. Fishing boats line the shingle, and in the distance can be seen the magnificent Hotel de Paris, named by Pierre le Francois, who bought Lord Suffield's summer residence here and turned it into a hotel. In 1894, it was later transformed into the building seen today, and helped establish Cromer as a 'fashionable resort'.

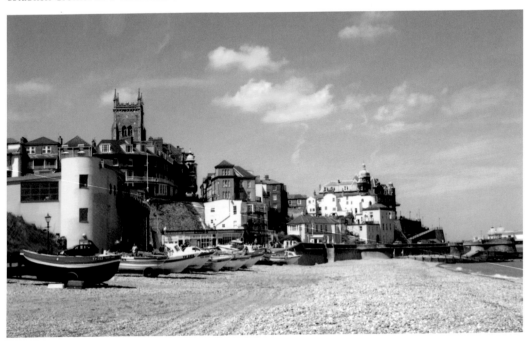

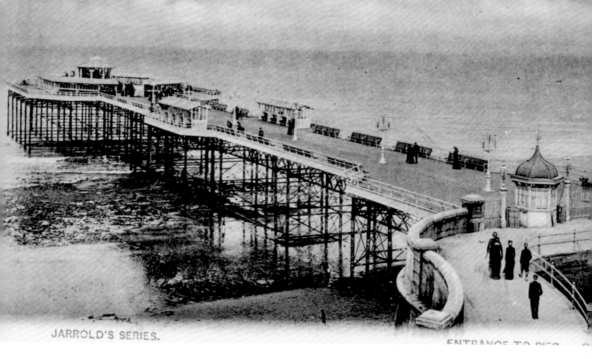

JARROLD'S SERIES.

Entrance to the Pier, Cromer, *c.* 1904
Cromer Pier is the only one on the North Norfolk coast. It dates from 1901, replacing an old jetty. The pier is frequently battered and damaged by the sea, most recently in December 2013. Its theatre is now famous for its Seaside Special summer season, one of the last of its kind in the country. The lifeboat station at the end of the pier is one of the busiest on the Norfolk coast. Cromer today is a busy town with a rich history, offering something for everyone who loves the seaside.

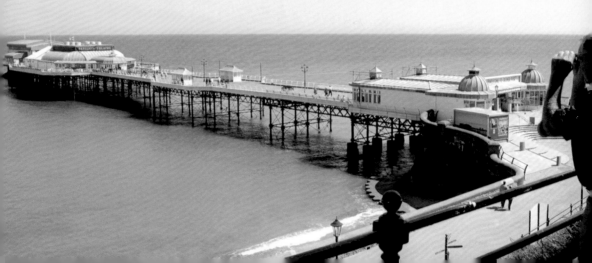

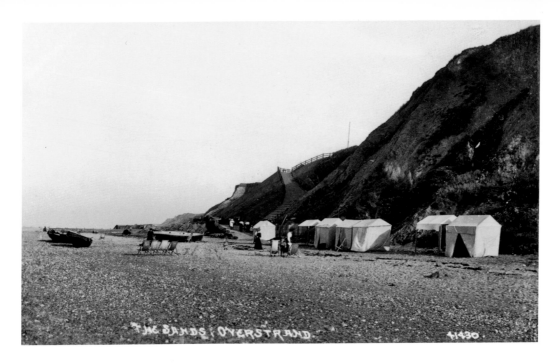

Overstrand

Lord Suffield was Lord of the Manor of Overstrand, and for a period of history it became a popular retreat for the rich and famous who had holiday residences there or stayed in the fine hotels. One of the largest hotels, the Overstrand Hotel built in 1903, was totally lost to the sea, as was part of the High Street. Now, a huge sea wall and wide promenade offer more protection from the relentless battering Overstrand sometimes gets.

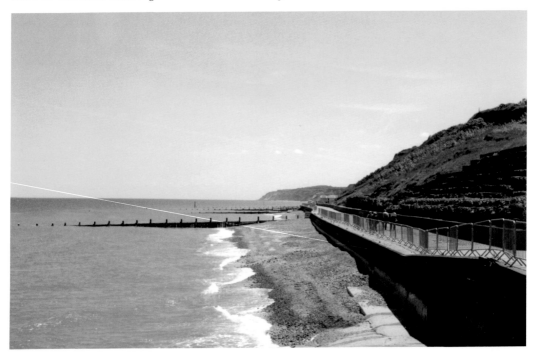

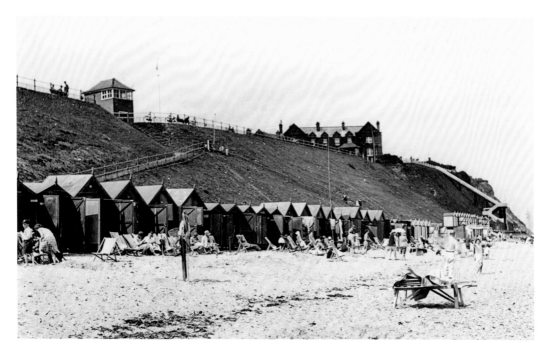

Mundesley, c. 1930

Mundesley had three magnificent hotels: the Grand Hotel (now restored as apartments), the Clarence (now a residential care home), and the Manor Hotel seen just above the cliffs which is still open today, although it has lost the steps to the sea. Mundesley never really developed as a big resort, but is popular today with holidaymakers as it has a fine Blue Flag beach. The tidal surge in December 2013 damaged the sea front café and shop.

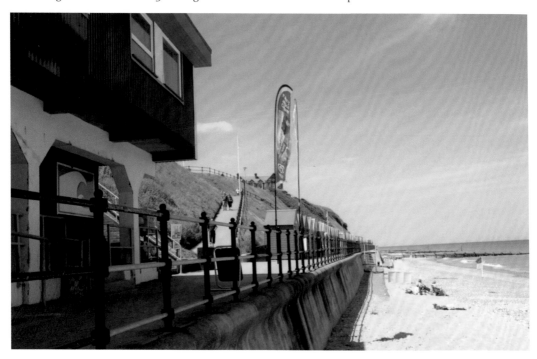

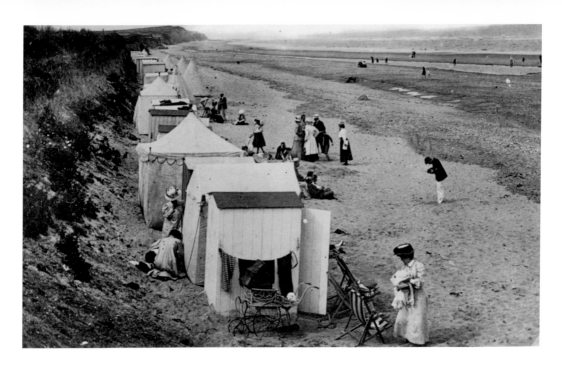

The Beach, Bacton-on-Sea, *c.* 1910

The village of Bacton is now known to many as the point of the North Norfolk coast where the North Sea natural gas terminus is located. Bacton is a popular area for campsites and has a fine beach, but again it is on a part of the coast that, despite the extensive sea wall defences, is at risk. The December tidal surge caused damage to the defences and property, but, unlike 1953 on the Norfolk coast, no lives were lost because of the improved defences and the earlier warnings that are now given.

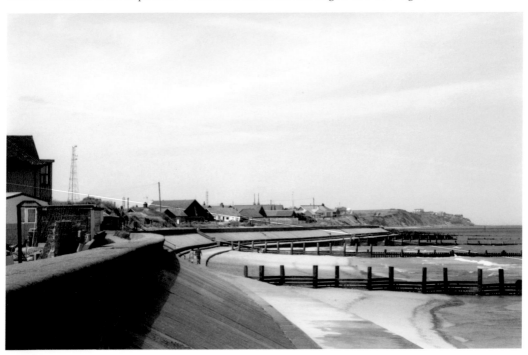

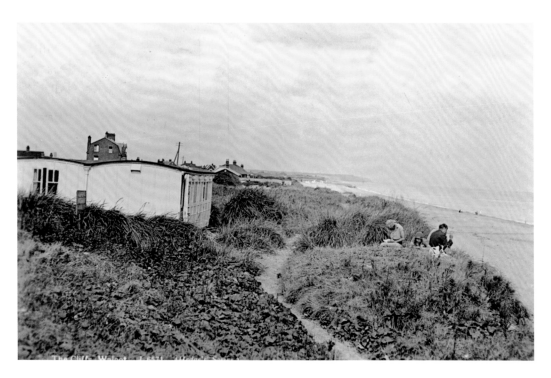

The Cliffs, Walcott, c. 1914
The B1159 coast roads runs right along the seafront here protected by extensive sea defences. Since Roman times well over a mile of the coast has been taken by the sea, including medieval villages like Waxham Parva and Markesthorpe. Early warning in December 2013 led to the evacuation of many people here and, despite extensive damage, there was no loss of life.

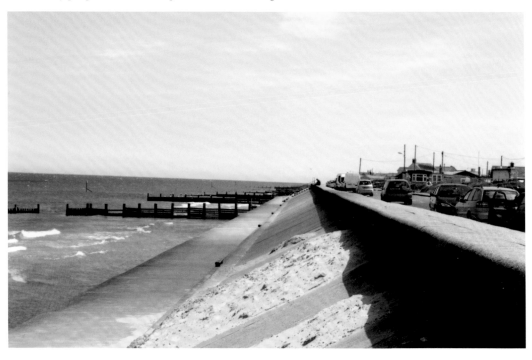

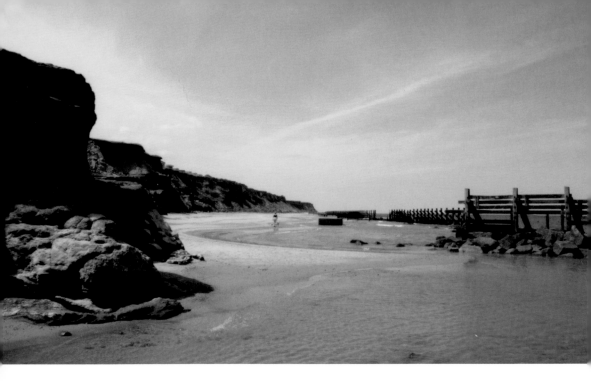

Happisburgh, c. 1914

In 2010, archeologists discovered flint tools here dated from over 800,000 years ago, making this the oldest evidence of human activity in the country. Happisburgh is one of the most threatened stretches of the North Norfolk coast. The soft cliffs are being worn away at an alarming rate by the dual action of the sea and rainwater permeating them, so that large sections break away and fall onto the sands below. The Coastal Concern Action Group was formed in 1998 to highlight the problem.

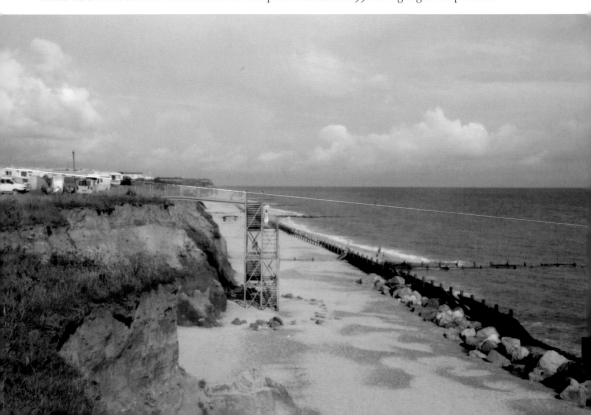

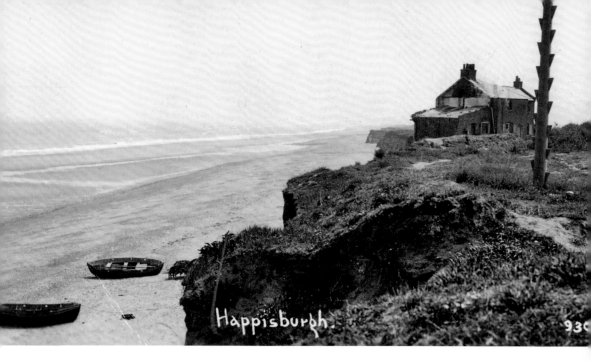

Happisburgh.

93c

Happisburgh, 2010

A metal staircase erected on 2003 (photographed by me in 2010) had to be removed in 2012 because of the erosion of the cliffs. The photographs show the wooden sea defences erected in 1959, but these have proved incapable of stopping the erosion despite the addition of the granite boulders. In the storms of December 2013, the last house on the left in Beach Road began to fall over the cliff and was demolished.

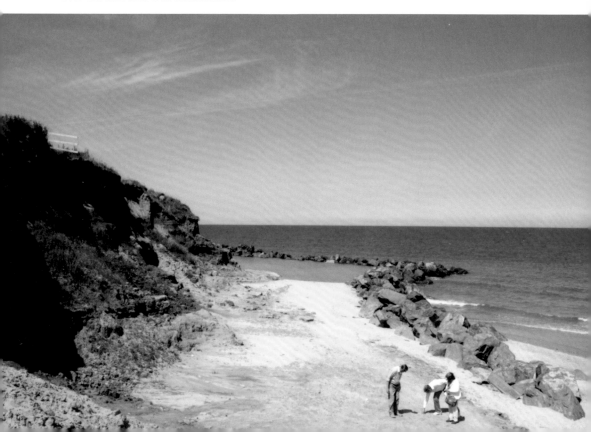

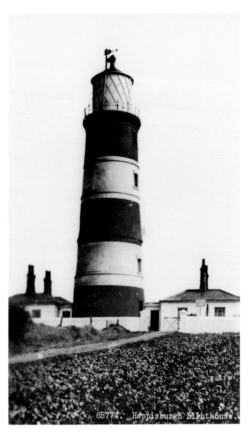

65774. Happisburgh Lighthouse.

Happisburgh Lighthouse
A new car park and toilets funded by the North Norfolk Pathfinder project have recently opened close to the well-known lighthouse, with its broad red and white bands. It has stood on the coast here since 1790. It was once one of a pair, with a lowlight that was demolished in 1883. This is the oldest working lighthouse in East Anglia and since 1990 the only independently run one. There are regular public open days.

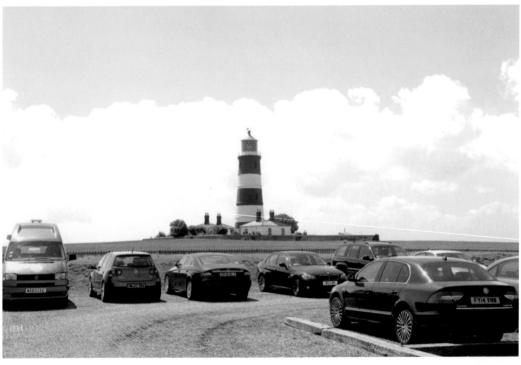

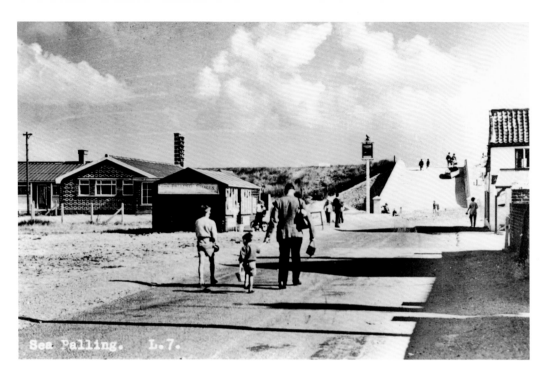

Sea Palling, *c.* 1960

Unlike Happisburgh, where it has been considered that the erosion cannot be stopped, there are plans to continue strengthening the defences here. This is a popular access to the beach from the nearby campsites with cafés, the Reefs Bar and coffee shops. The beach here is one of four beaches in Norfolk in 2014 awarded a Blue Flag, the others being at Sheringham, Cromer and Mundesley.

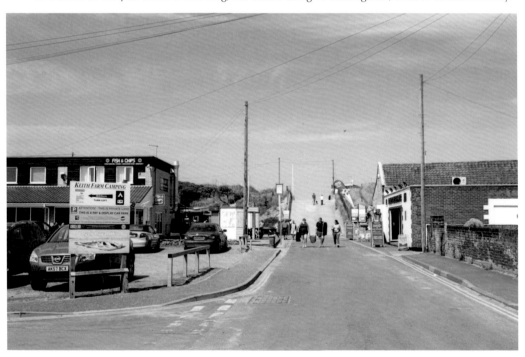

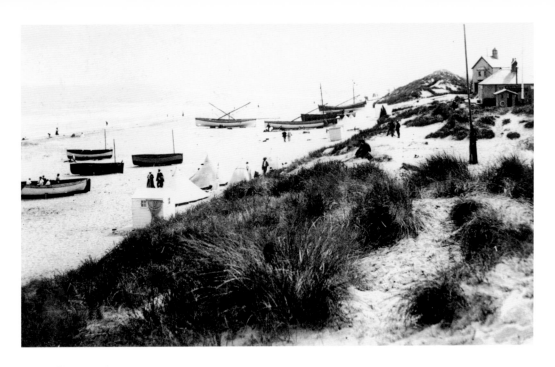

Sea Palling Beach, c. 1909

All types of sea defences have been tried at Sea Palling to protect this small, popular stretch of the coast and the agricultural land behind it. In 1954, a seawall was built and in the 1990s nine offshore rock reefs were constructed. There is a lifeguard hut and the Sea Palling Independent Lifeboat Station here. As well as the beautiful beach, the water quality at Sea Palling is particularly good and it is a popular place for swimming, sheltered by the reefs.

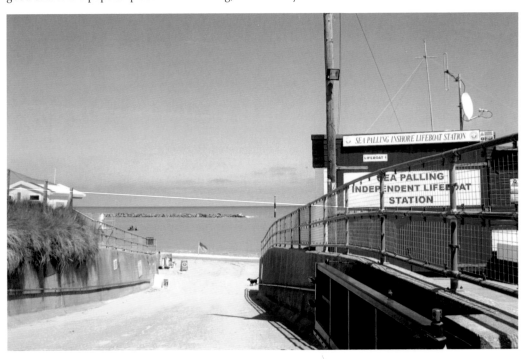

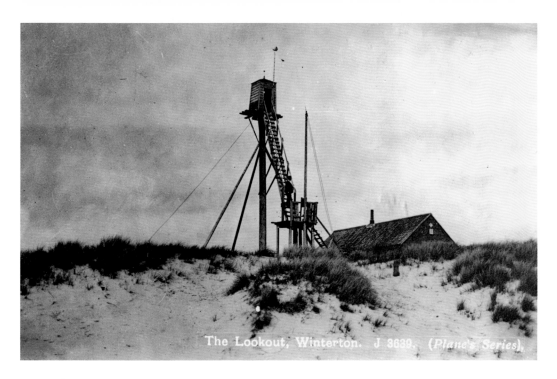

The Lookout, Winterton. J 3639. (Plane's Series).

Winterton

The lookout at Winterton was renamed Winterton-on-Sea in 1953 to avoid confusion with Winterton in Lincolnshire. Today, there is a Coastwatch station here as the coastal waters, with the notorious Happisburgh Sands, are treacherous. This is an area of dunes and lovely beaches.

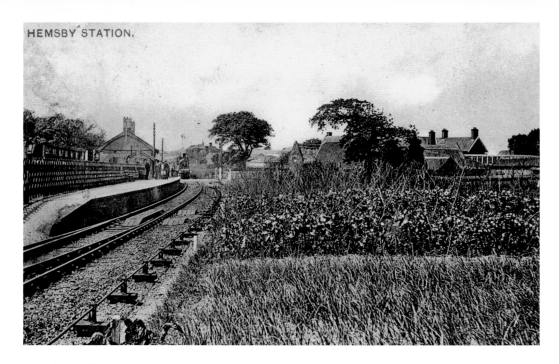

Hemsby Station, *c.* 1906

Hemsby station was originally on the Great Yarmouth & Stalham line, until becoming part of the larger Midland and Great Northern network. The station here was particularly busy with holidaymakers coming to the holiday camps at Hemsby, before nearly everyone was able to come by car. The line opened in 1878 and closed in 1959. Just like the Great Yarmouth Beach station that it served, it too was demolished. The closest we can get today is by staying at the Station House in the village.

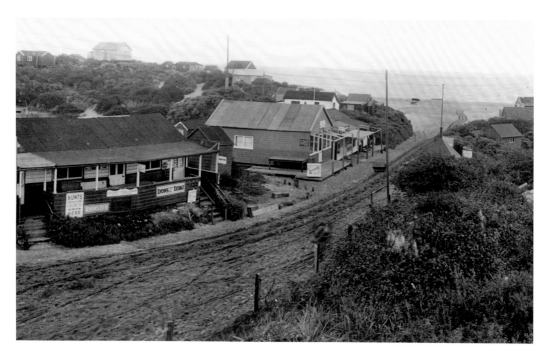

The Gap, Hemsby, *c.* 1950
Always a busy and popular access point to the beach, especially with the number of holiday camps and caravan parks in the vicinity, this has developed over the last sixty years into a modern amusement and fast food area, full of bright lights and music. Hemsby was severely hit by the December 2013 gales, and at least seven bungalows were seriously damaged at the Marrams and some completely lost to the sea.

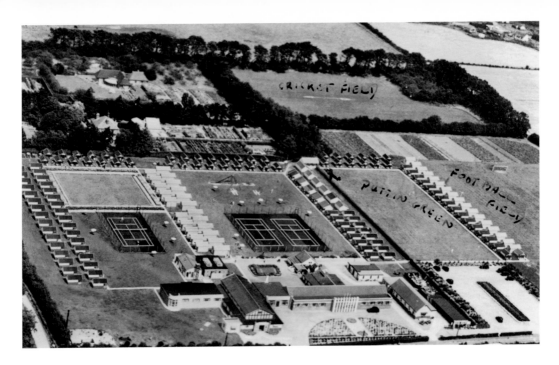

Seacroft Holiday Camp, Hemsby on Sea, *c*. 1950
Seacroft was one of the pioneer holiday camps and began in the 1920s, owned for many years by Jack Bishop and his family. It was then run by Pontins, but since 1998 it has been part of the Richardson's Holiday Villages group and specialises in adult-only holidays. Pontins also had another very large holiday camp, which could accommodate 2,440 holidaymakers, opposite, on Beach Road. This closed in 2008 and the site remains derelict, awaiting redevelopment.

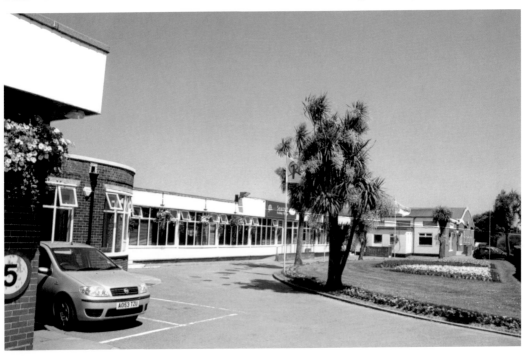

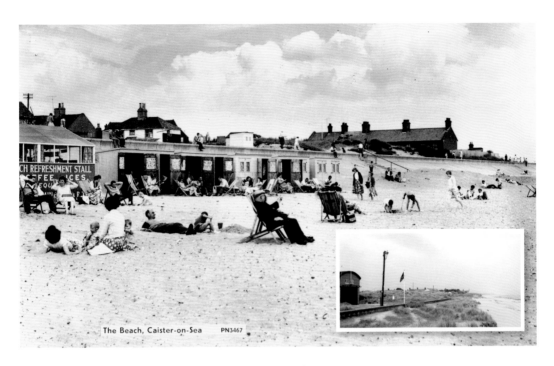

The Beach, Caister-on-Sea PN3467

The Beach, Caister on Sea, *c.* 1928 (Inset *c.* 1960)

Caister is defended by a wall and the dunes, but the sea continues to sweep away buildings. The old Beach Café has long gone, and the recent heavy seas exposed the old ruins of the Manor House Hotel, which was claimed by the sea in 1941. The men of Caister have been saving lives for centuries. The fishermen along the coast organised beach companies for rescue, and to earn income from salvage. The Caister Company was formed in 1794, and the first lifeboat stationed here in 1845. Since 1969, Caister has maintained an independent lifeboat service.

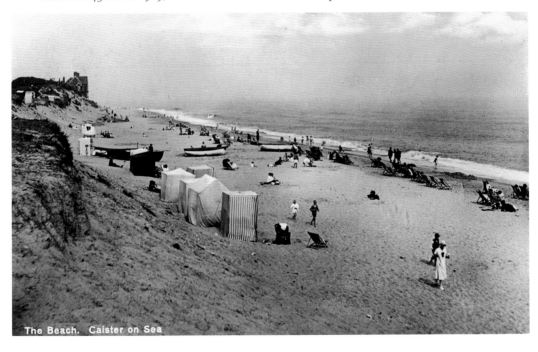

The Beach. Caister on Sea

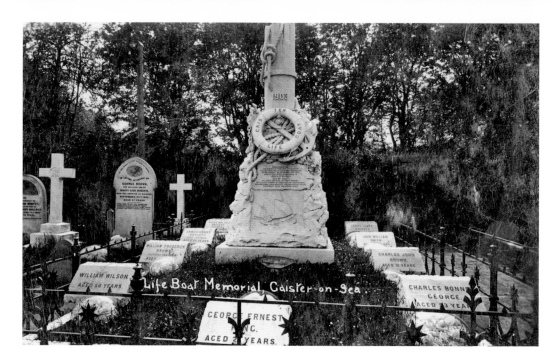

Life Boat Memorial, Caister on Sea

During the Great Storm of 1901, the Caister lifeboat *Beauchamp* was launched at night in tremendous seas but overturned. Three men were saved but eight men lost their lives, leaving forty-three children fatherless. When the coroner suggested they might have been turning back, one of the beach rescuers stated, 'They would never give up the ship ... Going back is against the rules.' This became their memorial and the Caister crew motto: 'Caister Men Never Turn Back'. The memorial stands to remind us of the selfless bravery of lifeboat crews around our coast.

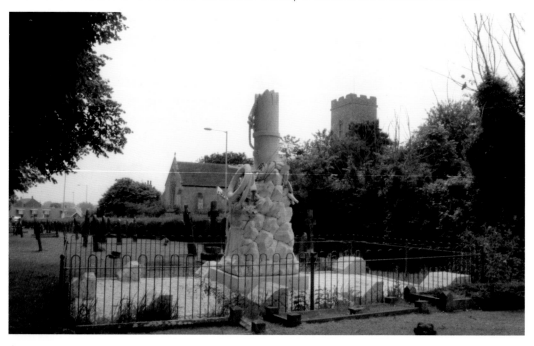

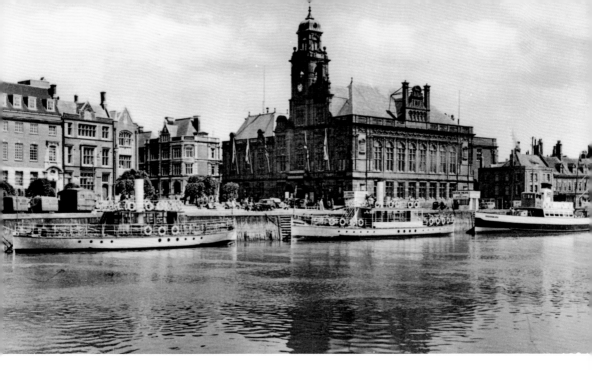

Town Hall Quay, Great Yarmouth

Yarmouth was an important fishing port from ancient times. For many years it was famous for its herring catches, with the Scottish herring girls arriving there for the weeks when the shoals of herring reached that part of the east coast. Silting-up has always caused problems with the port, but there has been extensive work in recent years since EastPort UK became owners in 2007. There is now a deepwater outer harbour so that the port can support the offshore energy sector and the wind farms in the North Sea.

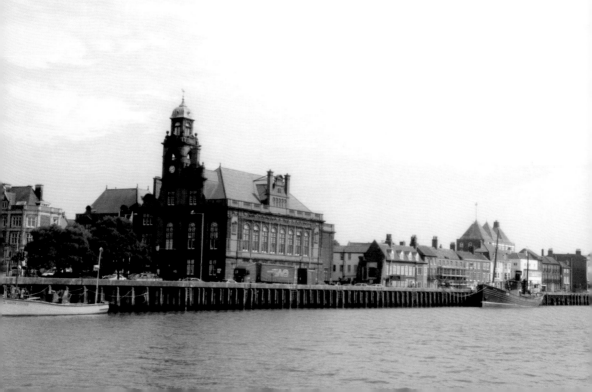

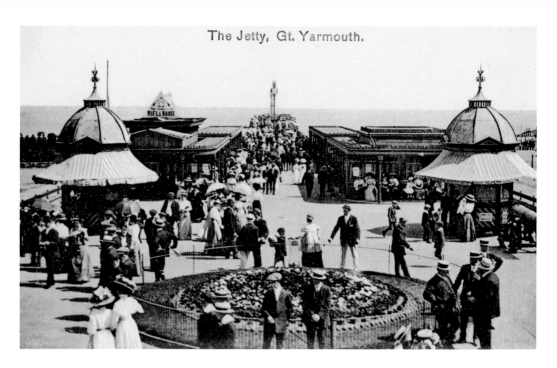

The Jetty, Gt. Yarmouth.

The Jetty, Great Yarmouth, c. 1910

By the 1850s, Yarmouth was well developed as a seaside resort known for its 'bracing air'. The jetty was built in 1809, and extended in 1846 and 1870. Samuel Morton Peto brought the railway from Norwich to the town in 1844, though many visitors would still arrive by paddle steamers. Charles Dickens would have seen these developments when he visited in 1847 and consequently used the town as a setting for part of David Copperfield. The jetty was considered too expensive to repair and demolished in 2012.

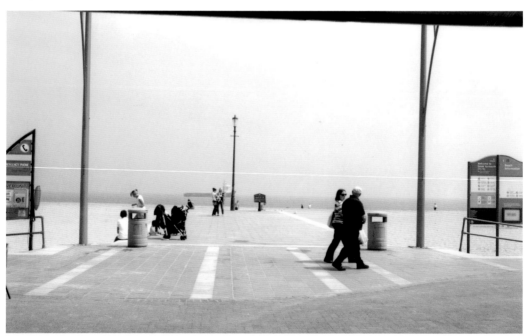

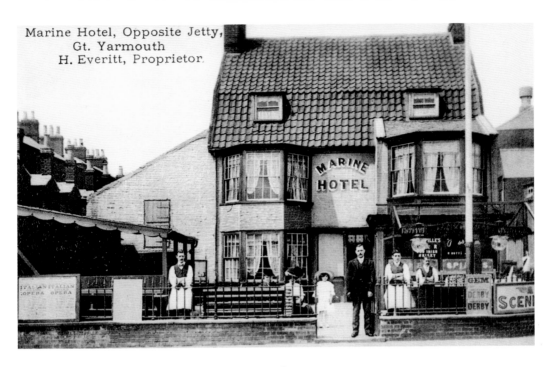

Marine Hotel, Opposite Jetty,
Gt. Yarmouth
H. Everitt, Proprietor.

Marine Hotel, Opposite Jetty, Great Yarmouth, *c.* 1910
This postcard was one way that H. Everitt, proprietor, advertised his seafront hotel to compete for the growing number of holidaymakers coming to the town. Dickens stayed at the Royal Hotel, formerly the Victoria, a little further along the Marine Parade. He described Yarmouth as the most wondrous sight his eyes had ever beheld. The Royal is still there, and the Marine is vigorously promoting itself.

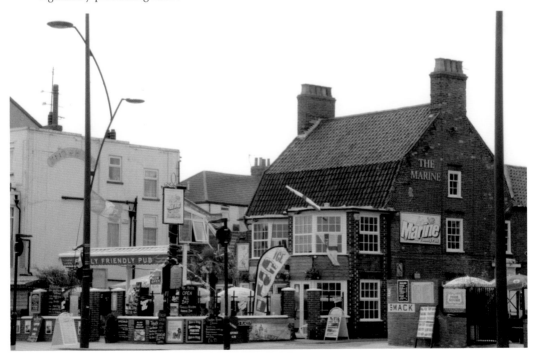

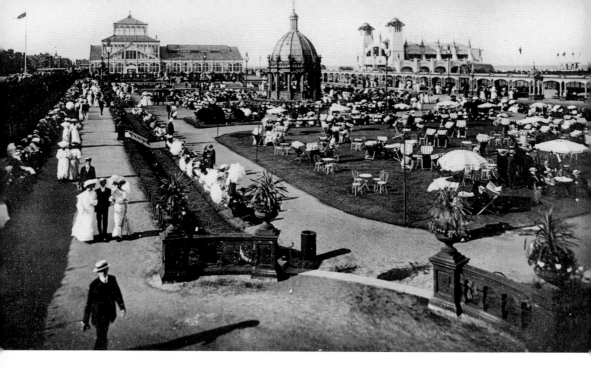

Yarmouth Wellington Gardens, *c.* 1910

The Wellington Pier was built in 1853, and is 623-feet long. It was rebuilt by the council in 1903 with a pavilion and the Winter Gardens were bought from Torquay and erected next to it in 1904. In the early twentieth century, it staged many successful traditional summer shows, until they went out of fashion. Family Amusements Ltd have now transformed the pier into an entertainments centre and the old theatre has been replaced by a tenpin bowling alley. The Winter Gardens closed in 2008 and face an uncertain future.

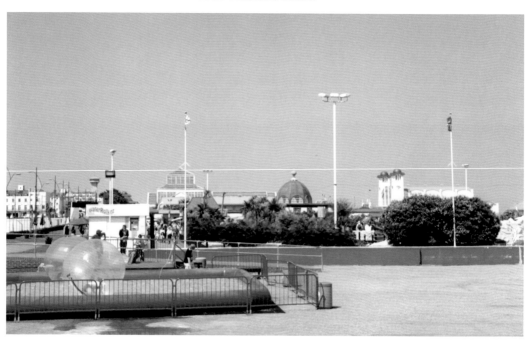

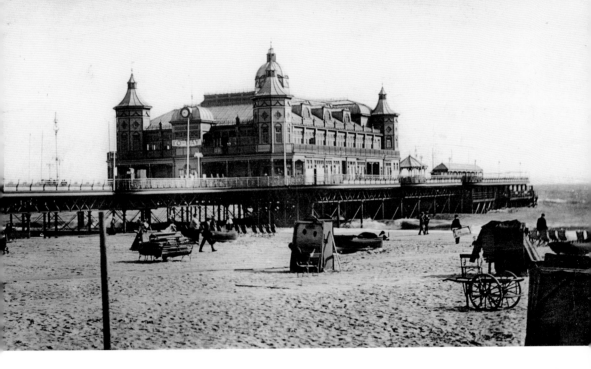

The Britannia Pier, *c.* 1907

The Britannia, at 623-feet long, opened in 1858 but was damaged by storms and struck by ships; so much so, that it was demolished and a new pier was opened in 1901. Its magnificent pavilion was destroyed by fire in 1909, rebuilt, and lost to fire again in 1914. The success of the Britannia was one of the reasons for the decline of the Wellington Pier. The present theatre, which still stages shows, is a much more functional building, now run by Family Amusements Ltd.

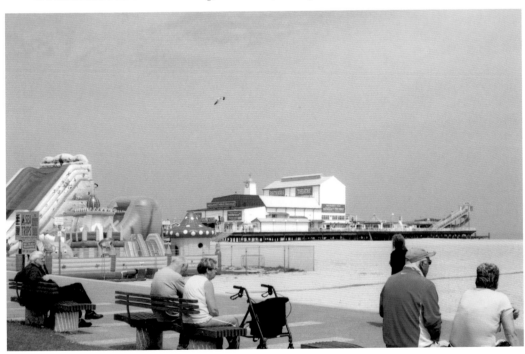

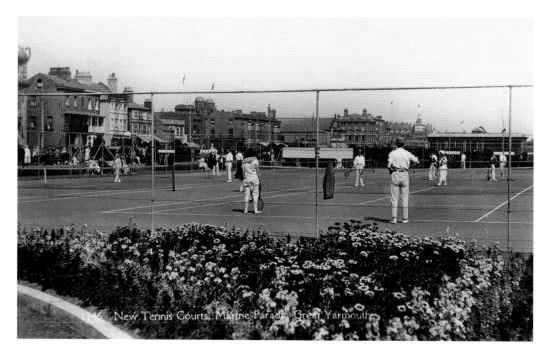

1146 New Tennis Courts, Marine Parade, Great Yarmouth

New Tennis Courts, Marine Parade, c. 1930

The Marine Parade began in 1856, and widened in 1876. Gardens, a boating lake, tennis courts and the Marina open-air theatre all stood between the two piers during the more leisurely years between the World Wars. The Marina Theatre was replaced by an indoor swimming pool and the new Sea Life Centre was constructed, all due to the changing demands of holidaymakers and an attempt to provide all-year attractions, not just for the summer season.

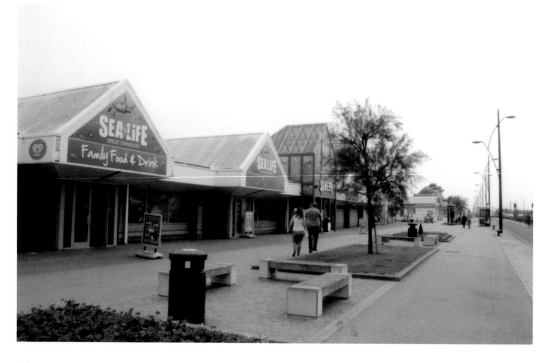

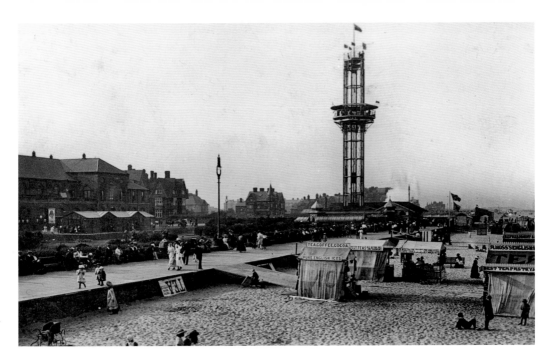

Revolving Tower from Brittania Pier, *c.* 1914

The Revolving Tower, at 130 feet high, was built by Thomas Warwick in 1897 and could take 200 passengers. This was the first of several of Warwick's towers built at resorts. It operated until 1939, but was scrapped in 1941. The tower in the Atlantis entertainment complex in the middle of the Marine Parade offers a modern view from its sky-deck coffee shop. The width of the Marine Parade now allows traditional horse-drawn carriage rides and a beach train to operate along its length separated from the traffic.

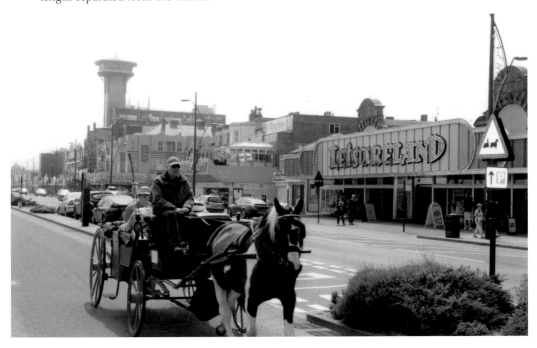

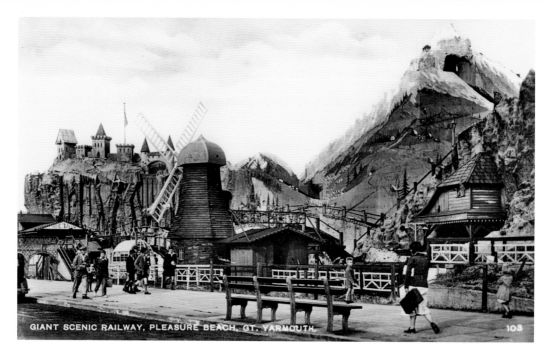

GIANT SCENIC RAILWAY, PLEASURE BEACH, GT. YARMOUTH. 103

Giant Scenic Railway, Pleasure Beach

The Pleasure Beach on the South Denes, opened in 1900, but was restricted at first to three attractions, one of which was a scenic railway (destroyed by fire in 1919 but rebuilt), and a Joy Rider covered roundabout. Now the Pleasure Beach, still with a very popular roller coaster, is one of the resort's premier features, offering rides for all ages, a 4D cinema, and a number of traditional fairground attractions.

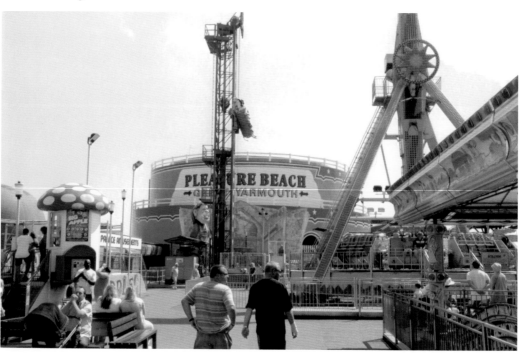

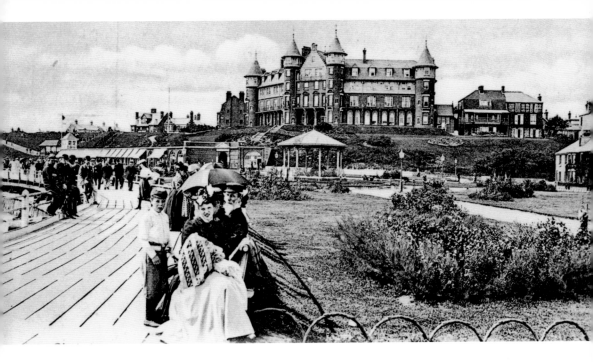

Cliff Hotel, Gorleston, *c.* 1904

Major investment at the turn of the twentieth century established Gorleston across the mouth of the Yare as a genteel rising resort, now known as Gorleston-on-Sea. The magnificent Cliff Hotel opened in 1898, and was the work of George John Skipper, the Norwich architect. Sadly, it was destroyed by fire in 1915. The old annex alongside it survived as the Cliff Hotel and has recently undergone a major facelift. The functional apartment block on the old site sadly does nothing to add to the skyline.

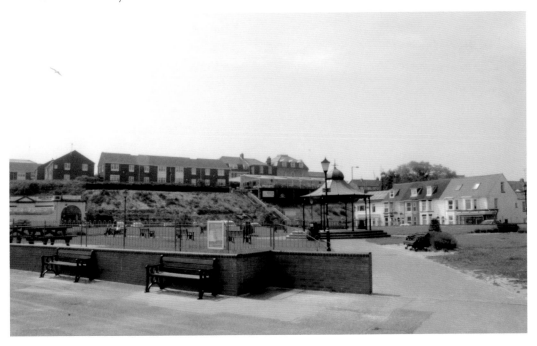

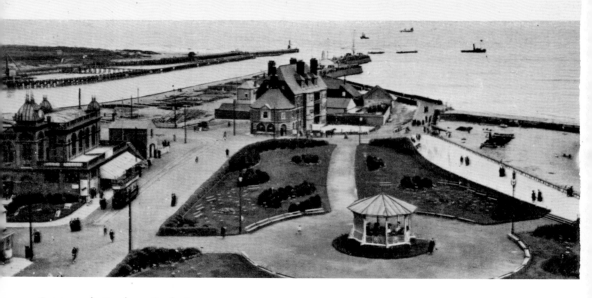

Promenade Gardens, Gorleston, *c.* 1912
Gorleston is a delightful, small resort maintaining much of its Edwardian charm. The Pavilion
Theatre built in 1901, on the left, still stages traditional summer shows and offers all-year
entertainment. The open-air bandstand was built at the same time and has recently been restored.
The Floral Hall and swimming pool were added alongside the green after the First World War.
With its grass-sloped cliffs, paddling pool, yacht pond and wonderful beach, Gorleston provides
somewhere a little quieter and different to balance Great Yarmouth's other attractions.

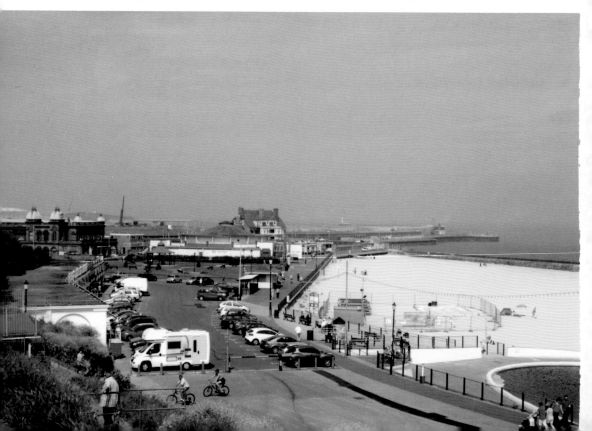